T0145435

Arsenal/Sin Documentos

by

Francesco Levato

~~INDEX~~

Introduction

Writing poetry entails pulling feelings, dreams, and memories from nothingness and bringing them to the page with words. That's why it's so easy. That's why it's almost impossible. On the other hand, blackout poetry is the art of pushing unnecessary/ extra/dishonest words into oblivion so that the true message, the meaning behind the jumble of words, can be revealed. Since the words are there, given, one could argue that it's an easier task. However, that is not the case. Every discourse is constructed with an intention, and this type of poetry demands a ruthless, fearless deconstruction of that discourse in order to reveal the truth. If poetry can speak truth to power, then what I'm choosing to call here revelation poetry speaks truth to power using power's original discourse.

Francesco Levato's *Arsenal/Sin Documentos* is a courageous book. More importantly, it is a necessary book. We are witnessing abuse and bigotry daily. We are living a ridiculously anti-immigrant rhetoric created to cause fear of the Other. This book slashes into the center of that issue and exposes its inherently racist core. Remember watching science fiction movies as a kid and being scared of aliens? Well, alien is, once again, a word used to instill fear, and to deliver a clear message:

"The removal of these aliens, must be prioritized."

But these are not aliens Levato is talking about. These aren't grey monsters with huge black eyes or evil green humanoid beings with disintegrating ray guns; he is discussing immigrants. People. Brothers and sisters in the struggle that is staying alive and caring for those we love. He is talking about children. Yes, the same children that got tear-gassed at la frontera.

Now imagine your life is so shitty you decided to leave everything you know behind to move to a different country. You have no money and fear abandoning your home, your language, your friends, your job, everything. Then you get here and the folks holding the American Dream receive you with "Choke holds/ neck restraints/baton to the head/electronic pulses to cause/Incapacitation/or pain." Welcome to the United States, cabrones.

Now stop imagining things. What you are about

to read is not about imaginary things, it's about everyday things that happen at the border. It's about rules and regulations that were created to control and dehumanize. It's about exposing the reality of a system that seems to be designed for a war and not for receiving individuals seeking asylum.

Like I said, stop imagining things. There are real words with real world implications ahead. Words like lethal and enforce. Words like authority and body and discretion. Words like taser and trauma and control. These words matter because they point to a flawed system. These words matter because Levato pulled them from a plethora of official documents he felt have "the capacity to affect an embodied subject both discursively and physically." They matter because they tell stories about the way other humans are seen, treated, processed. They matter because they are the law of the land, sanctioned by those in power and applauded by many.

There is a point in the career of every writer where he or she will have to decided if politics are going to be part of their oeuvre. Even deciding that they won't is a political move. I respect that. However, fully engaging is something I respect much more, and that is exactly what Levato has done here. There is no pandering. There is no sugarcoating. And there is Spanish. This level of engagement is the literary equivalent of standing in the middle of the road a few seconds after the cops drove by, one hand squeezing your crotch and the other held up high, middle finger flying. Eso merece respeto.

Perhaps the beauty of *Arsenal/Sin Documentos* is that it exposes truth while also leaving the door open for the reader to discover more. For example, it includes the instructions for immigrants who want to become citizens. Among those requirements is knowledge of English. Yeah, and then you remember there is no federal law establishing English as the official language of the United States...

I'm done. Turn the page and cross a frontera. Frontera narratives matter now more than ever, and you're about to read a crucial one.

- Gabino Iglesias, author of Zero Saints and Coyote Songs

Acknowledgements

With thanks to Moria Books, who published an excerpt of the erasure poem *Policy* in chapbook form, and also to the editors of *Dream Pop Journal*, *FIVE:2:ONE*, *Matter*, *Otoliths*, and *SunStruck Magazine,* where some of these poems first appeared.

- **POLICY.01**
- Levels of Behavior/Resistance

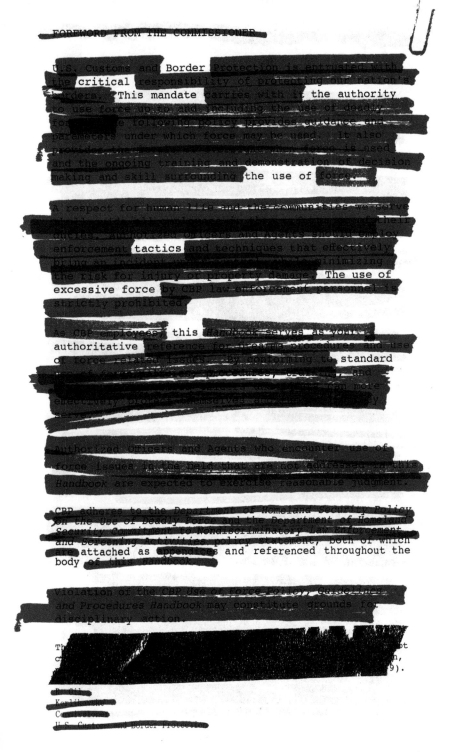

U.S. Customs and Border Protection is entrusted with the **critical** responsibility of protecting our nation's borders. This mandate carries with it the authority to use force up to and including the use of deadly force. The following policy provides guidance and parameters under which force may be used. It also ~~provides guidance~~ ~~force is used~~ and the ongoing training and demonstration of decision making and skill surrounding the use of force.

A respect for human life and the communities we serve ~~their~~ duties. Authorized officers and Agents should employ enforcement **tactics** and techniques that effectively bring an incident ~~minimizing~~ the risk for injury or property damage. The use of excessive force by CBP law enforcement personnel is strictly prohibited.

As CBP employees, this *Handbook* serves as your **authoritative** reference for firearms procedures and use of force related issues. By conforming to **standard** ~~procedures~~ ~~more~~ ~~effectively~~

Authorized Officers and Agents who encounter use of force issues in the field that are not addressed in this *Handbook* are expected to exercise reasonable judgment.

CBP adheres to the *Department of Homeland Security Policy on the Use of Deadly Force* and the *Department of Homeland Security Commitment to Nondiscriminatory Law Enforcement and Screening Activities* policy statement, both of which are **attached as appendices** and referenced throughout the body of this *Handbook*.

Violation of the *CBP Use of Force Policy, Guidelines and Procedures Handbook* may constitute grounds for disciplinary action.

R. Gil
Kerlikowske
Commissioner
U.S. Customs and Border Protection

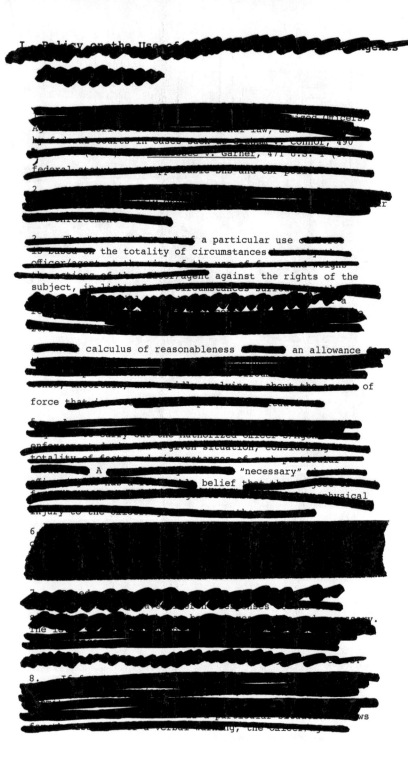

I. Policy on the Use of ▓▓▓▓▓▓▓▓▓▓▓▓▓▓▓▓▓▓▓▓▓▓▓▓▓▓

▓▓▓▓▓▓▓▓▓▓▓▓▓▓▓▓▓▓▓▓▓▓▓▓▓▓▓▓▓▓▓▓▓▓▓▓▓▓▓

Ag▓▓▓▓▓▓▓▓▓▓▓▓▓▓▓▓▓▓▓▓▓▓▓▓▓▓▓▓▓▓ officers,
by federal courts in cases such as *Graham v. Connor*, 490
▓▓▓▓▓▓▓▓▓▓▓▓ *Tennessee v. Garner*, 471 U.S. 1 ▓▓▓▓▓
federal stat▓▓▓▓▓▓▓ applicable DHS and CBP policies.

2. ▓▓
▓▓
▓▓ enforcement.

3. The ▓▓▓▓▓▓▓▓▓▓ of a particular use of ▓▓▓▓▓
is based on the totality of circumstances ▓▓▓▓▓▓▓▓▓▓
officer/agent at the time of the use of force, and weighs
the actions of the officer/agent against the rights of the
subject, in light of ▓▓▓ circumstances surrounding the ▓▓▓
▓▓▓▓▓▓▓▓▓▓▓▓▓▓▓▓▓▓▓▓▓▓▓▓▓▓▓▓▓▓▓▓▓▓▓ a
re▓▓▓
▓▓▓

4. ▓▓▓▓▓▓ calculus of reasonableness ▓▓▓▓▓▓▓ an allowance ▓▓▓
▓▓
▓▓▓▓▓▓▓▓▓▓▓▓▓▓▓▓▓▓▓▓▓▓ about the amount of
force that ▓▓▓▓▓▓▓▓▓▓▓▓▓▓▓▓▓▓▓▓▓▓▓▓▓▓▓▓▓▓

5. ▓▓
enforcement to carry out the authorized officer's/agent
▓▓▓▓▓▓▓▓▓▓▓▓▓▓▓▓▓ given situation, considering ▓▓▓▓▓
totality of facts and circumstances of such particular
of▓▓▓▓▓▓. A ▓▓▓▓▓▓▓▓▓▓▓▓▓▓▓▓▓▓ "necessary" ▓▓▓▓▓▓
of▓▓▓▓▓▓ has a reasonable belief that the subject ▓▓▓▓▓
▓▓▓▓▓▓▓▓▓▓▓▓▓▓▓▓▓▓▓▓▓▓▓▓▓▓▓▓▓ physical
injury to the officer/▓▓▓▓▓▓▓▓▓▓▓▓▓▓▓▓▓

6. ▓▓
o▓▓

7. ▓▓▓▓▓▓▓▓▓▓▓▓▓▓▓▓▓▓▓▓ are ▓▓▓▓ of cases ▓▓▓▓▓
s▓▓▓▓▓▓▓▓▓▓▓▓▓▓▓▓▓▓▓▓▓▓▓▓▓▓▓▓▓▓▓▓▓ necessary.
The re▓▓▓▓▓▓▓▓▓▓▓▓▓▓▓▓▓▓▓▓▓▓▓▓▓▓▓▓▓▓▓▓
▓▓

8. If ▓▓▓▓▓▓▓▓▓▓▓▓▓▓▓▓▓▓▓▓▓▓▓▓▓▓▓▓▓▓▓▓▓▓▓▓▓▓
▓▓▓▓▓▓▓▓▓▓▓▓▓▓▓▓▓▓▓▓▓▓▓▓ particular ▓▓▓▓▓▓▓ ws
f▓▓▓▓▓▓▓▓▓▓▓▓ a verbal warning, the officer/▓▓▓▓▓

a[redacted]t
t[redacted]
warra[redacted]

1. [redacted] involving the use of force

A. Objectively Reasonable and the Totality [redacted]

1. The reasonableness inquiry [redacted] of force is an objective one: the question is whether the officer's/agent's actions are objectively reasonable in light of the totality of facts and circumstances confronting him or her, without regard to underlying intent or motivation.

2. In determining whether a use of force is objectively reasonable, an Authorized Officer/Agent must give careful attention to the totality of facts and circumstances of each particular case, including:

 a. Whether the subject poses an imminent threat to the safety of the officer/agent or others;

 b. The severity of the crime at issue;

 c. Whether the subject is actively resisting seizure or attempting to evade arrest by flight;

 d. Whether the circumstances are tense, uncertain and rapidly evolving; and

 e. The foreseeable risk of injury to involved subjects and others.

[redacted]

a[redacted]
s[redacted]

c[redacted] or

[redacted] conditions.

Levels of Behavior/Resistance

Compliant: a subject who is compliant/cooperative with an authorized officer's/agent's control efforts.

Passive Resistance: a subject who is not believed to represent an immediate threat, and who is not offering physical resistance, but is not cooperative.

Active Resistance: a subject who offers physical or mechanical resistance to an officer's/agent's control efforts.

Assaultive Resistance: a subject whose resistance causes, or has the potential to cause, physical injury to the officer/agent, others, or self.

This includes a subject's attempts (or apparent intent) to make physical contact.

- **Policy.02**
- Q. Es fácil comprender lo que el agente está diciendo
- From Hand-Held Stun Gun for Incapacitating a Human Target

C. Use of Less-Lethal Force [1]

1. Less-lethal force is force that is not likely to cause serious physical injury or death.

2. Any use of less-lethal force must be both objectively reasonable and necessary in order to carry out the Authorized Officer's/Agent's law enforcement duties.

3. Less-lethal devices/weapons may be used in situations where empty-hand techniques are not sufficient to control disorderly or violent subjects.

D. Use of Deadly Force

1. Deadly force is force that is likely to cause serious physical injury or death.

2. The *Department of Homeland Security Policy on the Use of Deadly Force* governs the use of deadly force by all DHS employees.

3. Authorized Officers/Agents may use deadly force only when necessary, that is, when the officer/agent has a reasonable belief that the subject of such force poses an imminent danger of serious physical injury or death to the officer/agent or to another person.

 a. Serious Physical Injury - injury which creates a substantial risk of death or which causes serious disfigurement, serious impairment of health or serious loss or impairment of the function of any bodily organ or structure or involves serious concussive impact to the head.

4. Except in limited circumstances during air or marine enforcement operations, discharging a firearm as a warning or signal is prohibited. Discharging a firearm at a person shall be done only with the intent of stopping that person from continuing the threatening behavior that justifies the use of deadly force.

5. Deadly force is not authorized solely to prevent the escape of a fleeing subject.

Deadly force against a fleeing subject is only authorized if there is probable cause to believe that:

 a. The subject has inflicted or threatens to inflict serious physical injury or death to the officer/agent or to another person; and

 b. The escape of the subject poses an imminent threat of serious physical injury or death to the officer/agent or to another person.

[1] Referenced in prior versions of our policy or applicable regulations as "intermediate force" or "non-deadly force" and used herein with the same purpose and effect.

6. Authorized Officers/Agents shall not discharge their firearms at the operator of a moving vehicle, vessel or aircraft unless deadly force is necessary — that is, when the officer/agent has a reasonable belief that the operator poses an imminent danger of serious physical injury or death to the officer/agent or to another person.

a. Such deadly force may include a moving vehicle aimed at officers/agents or others present, but would not include a moving vehicle merely fleeing from officers/agents unless the vehicle or the escape of the subject poses an imminent threat of serious physical injury or death to the officer/agent or to another person.

b. The hazard of an uncontrolled conveyance shall be taken into consideration prior to the use of deadly force.

7. Firearms shall not be fired solely to disable motor vehicles, vessels, aircraft or other conveyances. The only exception is that Authorized Officers/Agents, when conducting maritime law enforcement operations, may use specifically authorized firearms and ammunition to disable moving vessels or other maritime conveyances.

8. Deadly force may be directed against dangerous or vicious animals in self-defense or in defense of another person.

9. Deadly force may also be used to euthanize an animal that appears to be seriously injured or diseased. In doing so, the Authorized Officer/Agent must be able to justify the use of deadly force to prevent the animal from additional suffering, eliminate a public health risk or to ensure public safety.

10. The act of establishing a grip, drawing a weapon or pointing a weapon does not constitute the use of deadly force.

E. The CBP Use of Force Continuum.

1. The CBP Use of Force Continuum is an instructional model used to describe the levels of force an Authorized Officer/Agent may need to utilize to gain control over a resistant subject.

2. While it describes each of the different levels of force that may be used in response to subject behavior, it is not necessary to mechanically apply every step of the CBP Use of Force Continuum.

3. An Authorized Officer/Agent may have to rapidly escalate or de-escalate through the continuum, depending on the totality of facts and circumstances of the particular situation.

4. Levels of Subject Behavior/Resistance:

a. Compliant - A subject who is compliant/ cooperative with an Authorized Officer's/ Agent's control efforts.

b. Passive Resistance - A subject who is not believed to represent an immediate threat or flight risk, and who is not offering physical resistance to an Authorized Officer's/Agent's control efforts, but not cooperative.

c. Active Resistance - A subject who offers physical or mechanical resistance to an Authorized Officer's/ Agent's control efforts.

(1) Mechanical Resistance - A type of active resistance, where a subject uses a mechanical or other object to resist an officer/agent's control efforts. The subject's efforts are not directed toward the officer/agent but rather appear intended to thwart an officer's/agent's control efforts by physically securing or holding to another object.

d. Assaultive Resistance (Physical Injury) - A subject whose resistance causes, or has the potential to cause, physical injury to the officer/ agent, others, or self. This includes a subject attempts (or apparent intent) to make physical contact in an attempt to control or assault the officer/agent.

e. Assaultive Resistance (Serious Physical Injury/Death) - A subject whose resistance causes, or has the potential to cause, serious physical injury or death to the officer/agent, others, or self.

5. Levels of Officer/Agent Response:

a. Cooperative Controls - Measures (including verbal commands) used to maintain control over a compliant subject.

b. Contact Controls - Physical measures taken when verbal commands and officer presence are not effective in gaining compliance. Contact controls may include measures such as strategic positioning, escort holds, joint manipulation or immobilization or touch pressure point stimulation.

c. Compliance Techniques - Actions taken when the subject is actively resisting the efforts of the officer/agent to establish and maintain control. Examples of compliance techniques include the use of Oleoresin Capsicum (OC) spray, strike pressure points, stunning techniques, takedowns, joint manipulations and use of an Electronic Control Weapon (ECW).

d. Defensive Tactics - Actions taken when a subject has either assaulted the officer/agent or ~~~~~~~~~~ and intent to do so. Examples of defensive tactics are concentrated strikes involving the use of empty-hand techniques (e.g., the use of body parts as weapons), the Collapsible Straight Baton (CSB) and the ECW ~~~~~~~~~~

e. Deadly Force - Actions taken when an authorized Officer/Agent has a reasonable belief that the subject of such force poses an imminent danger of serious physical injury or death to the officer/agent or to another person.

E. Use of Safe Tactics

1. Authorized Officers/Agents should seek to employ enforcement tactics and techniques that effectively bring an incident under control, while promoting the safety of the officer/agent and the public, and minimizing the risk for unintended injury and/or property damage.

2. Except where otherwise required by inspections or other operations, Authorized Officers/Agents should avoid standing directly in front of or behind a subject vehicle. Officers/agents should not place themselves in the path of a moving vehicle or use their body to block a vehicle's path.

3. Authorized Officers/Agents should, whenever reasonable, avoid placing themselves in positions where they have no alternative to using deadly force.

4. Authorized Officers/Agents shall not discharge their firearms in response to thrown or launched projectiles unless the officer/agent has a reasonable belief, based on the totality of circumstances (to include the size and nature of the projectiles), that the subject of such force poses an imminent danger of serious physical injury or death to the officer/agent or to another person.

Officers/agents may be able to obtain a tactical advantage in these situations, through measures such as seeking cover or distancing themselves from the immediate area of danger.

F. DHS Commitment to Nondiscriminatory Law Enforcement and Screening Activities

Q. Es fácil comprender lo que el agente está diciendo.

The word *comprender* means to understand something after watching,

listening to, or reading it. Hence,

response C, *entender* ("to understand"), is the best synonym.

Response E, *desentender*, is the exact opposite of the correct answer;

in fact, it is *entender*, but with a negative prefix added to it,

thus giving it the meaning of "to misunderstand."

from Hand-Held Stun Gun for Incapacitating a Human Target

In practice, it is critical to produce contractions
of skeletal muscles sufficient to prevent the voluntary
use of the muscles encountered during normal locomotion
of an individual's body.

Twitching of the skin
does not indicate that contractions necessary
are taking place.

...

Fig. 1

Trigger, microprocessor, power, switch,

primary transformer, capacitor, output transformer, first conducting wire,

first dart, motive power means, tissue, second dart, second conducting wire,

ground.

...

Determining whether the force used was constitutionally excessive,
we begin by considering the nature and quality of the force.

...

If contractions are not produced, the apparatus is not functioning in the manner desired.

If there are no contractions, the individual can "walk through," or be trained to walk through,
being hit with darts which conduct electricity through the individual's body.

...

Compressed nitrogen to propel aluminum darts,

 tipped with stainless steel barbs connected by insulated wires

toward target at over 160 feet per second.

 On striking, a 1200 volt charge, the impulse overrides

central nervous system, paralyzing muscles, rendering target limp

and helpless.

 ...

 An incredible burning and painful feeling, a locking
 of all joints and muscles, a falling hard to the floor.

 ...

In operation, trigger is pressed to send a signal to microprocessor. Microprocessor opens switch. Power flows through primary transformer, capacitor, and output transformer. The output goes into wire and dart. Once the current flow reaches dart, current is directed by wire to motive power means (i.e., black powder) to activate motive power means to project the first and second darts through the air to the individual who is the target.

 ...

 There are only so many ways that a person can be extracted against their will,
 and none of them is pretty.

 ...

When the darts contact the individual's body, pulses from dart travel into tissue, from the tissue into the second dart, from the second dart into the second conducting wire, and through the second connecting wire to the ground in the weapon.

 ...

Subject was obstinate to the bitter end, "resist[ing] being handcuffed by keeping her arms tense."

> *The officers nevertheless defused the situation without causing serious harm:*

Subject suffered only minor scars, her daughter was born healthy and subject's counsel confirmed that the child remains healthy.

...

Without admitting to having committed each of the above offenses, by signing this document I acknowledge receipt of this notice of infraction, and promise to respond as directed.

- **Policy.03**
- Levels of Response

- Nature and Quality of Intrusion
- Q. Hay que esclarecer todo el proceso

I

A. Authorized Officers/Agents

For the purposes of t .

 a ;

 b ;

 c. All

 d. Internal Affairs Special Agents and Investigators, and

 e. . as designated by Commissioners of the , or the Chief, office of Border Patrol (hereinafter referred to as "Assistant Commissioners" or the Commissioner, and the Director of FLETC.

An Assistant Commissioner (AC) may an individual or submitting a written justification this designation to the Commissioner, through the of training and development (). This justification shall the FLETC comment prior submission to Commissioner.

Additional guidance for designated armed personnel by the Director of are not considered to be authorized officers/

P () justifi C

 Director the Commissioner

 a All
 that
 issued.

... authority
provided

......

................ governed
.......... and applicable

..

............ .. carry a,
individually or as a class,
................. of CBP;

.. and CBP credentials
....;

a. maintain proficiency, as set forth ..
..........., .. the use of firearms they ...
.............. and the provisions
of ... policy

......... all other requirements and standards ...
......... this ...

.......................... s

1. Authorized officers/agents are requi...
CBP daily
uniformed ... enforcement
.......................................
........... (e.g.,).

2 ..

..
duty

b. In threat......

.............

..

...........
........................ Equipment
.... specifically approved

. Authorized officers/agents may

handbook.

. Authorized officers/agents

to carry and to bear . This
requirement does not apply to officers/agents involved in
an authorized undercover operation or when approved in

. Authorized officers/agents

a round
in the chamber and magazine
chambers loaded.

only issued/approved ammunition may

. Authorized officers/agents,
, fully loaded,
their primary hand

. All authorized officers/agents shall be issued only
Based upon availability and
concurrence first operational
component, operational/agent may as secondary
as secondary handgun.

a. An authorized officer/agent shall not be

operational component
and the Director of .

. Except as provided herein, authorized
only one handgun on their person at a time.
Written authorization to handguns as the
must be obtained from the responsible official
, with the concurrence of the respective national
component AC.

11

law enforcement duties

11

1

Levels of Response

Cooperative Controls: used to maintain control over a compliant subject.

Contact Controls: when verbal commands and officer presence
are not effective in gaining compliance—

strategic positioning, escort holds, joint manipulation, immobilization,
pressure point stimulation.

Compliance Techniques: when the subject is actively resisting
the efforts of the officer/agent to establish and maintain control—

Oleoresin Capsicum spray, strike pressure points, stunning techniques, takedowns,
joint manipulations, use of an Electronic Control Weapon.

Defensive Tactics: when a subject has either assaulted the officer/agent
or is displaying a willingness and intent to do so—

concentrated strikes (the use of body parts as weapons),
the Collapsible Straight Baton, the Electronic Control Weapon.

Deadly Force: when an officer/agent has a reasonable belief—

Nature and Quality of Intrusion

Here, it is undisputed that A was unarmed, no contraband
was found in his possession, and he was placed in handcuffs
for all encounters with defendants.

Taking as true that D kicked A's ankles,

A told F about his medical needs which D and K were aware of,

D and K permitted the intrusive beating of plaintiff

by P and N with batons even though moments earlier

they indicated that all was well.

L also participated with D, K, P, and N in beating and kicking A,

and holding him on the ground with their body weight

pressing on his back and neck.

V then tasered A, even though A remained handcuffed, face down,

and as the video and civilian witnesses attest, passive

but for crying out for help.

S and B acknowledge that they restrained A's legs after he was tasered,

and they then ziptied an unresponsive A's legs.

...

Standing in the shoes of the "reasonable officer,"

the court asks whether the severity of force applied

was balanced by the need for such force

 considering the totality of the circumstances,

including (1) the severity of the crime at issue,

(2) whether the suspect posed an immediate threat

to the safety of the officers or others, and (3)

 whether the suspect was actively resisting arrest

or attempting to evade arrest by flight.

. . .

We don't know what would have happened had they just left him alone,

not tasered him, gotten him to a hospital in enough time

I think that is the cumulation of all the factors player – played a role,

And I – it's difficult to – to eliminate or separate the factors completely. . . .

And just as in many – many questions that deal with multiple –

either multiple injuries or multiple complex physiologic processes,

we cannot separate and remove any of those processes from the ultimate effect

because they play some role, they – they cause some effect

which may have been sufficient to – to cause the ultimate effect.

 So I – I believe that just cannot be separated.

Q. Hay que esclarecer todo el proceso.

Responses A, B, D, and E

 ("to find," "to concentrate," "to worsen," and "to crush")

 are completely unrelated to the meaning of esclarecer.

40

- **Policy.04**
- Issue #1—Re-identification of an Individual's Race and Ethnicity

13. Only Authorized Officers/Agents may discharge a CBP-issued firearm, except during CBP-authorized training, events or activities and military or law enforcement joint operations.

D. Flying Armed on a Commercial Aircraft

Authorized Officers/Agents may carry their CBP-issued firearms in the cabin of commercial aircraft in accordance with applicable regulations, policies and procedures.

2. Each officer/agent who carries a CBP-issued firearm while traveling on board a commercial aircraft must complete the CBP-approved Law Enforcement Officers Flying Armed training course. This course will be readily available to all officers/agents.

3. Any Authorized Officer/Agent traveling aboard an aircraft while armed must at all times keep their CBP-issued firearm:

 a. Concealed and out of view, either on their person or in immediate reach, if the officer/agent is not in uniform; or

 b. On their person, if the officer/agent is in uniform.

4. No officer/agent may place a weapon in an overhead storage bin.

5. Under no circumstances shall an Authorized Officer/Agent relinquish their CBP- issued handgun to the pilot or any member of the flight crew, or allow the weapon to be stored in the crew compartment of the aircraft.

 a. If an officer/agent is directed by anyone to check their handgun, the officer/agent should request assistance from the appropriate security officials in order to resolve the issue: first, the airport's Ground Security Coordinator (GSC) and then the TSA Federal Security Director (FSD).

 b. Any officer/agent who has been denied boarding shall notify their immediate supervisor at the earliest practicable time. A written report of this denial shall be forwarded to the Director of UFCE, through the RO, outlining the details of the occurrence.

E. Alcohol and Medication

1. Authorized Officers/Agents are prohibited from consuming alcoholic beverages while carrying CBP-issued weapons, except when engaged in authorized undercover activities necessitating the consumption of alcoholic beverages.

[1] Carriage of firearms aboard aircraft is governed by 49 C.F.R. § 1544.219: Carriage of accessible weapons.

In these cases, the consumption of alcoholic beverages shall be limited to an amount that does not impair the officer's/agent's judgment.

2. Authorized Officers/Agents shall not carry a firearm while taking medication that impairs their judgment and/or ability to safely carry, control or use a firearm.

F. Revocation of Authorization to Carry CBP-Issued Firearms

1. The authority to carry a CBP-issued firearm may be temporarily or permanently revoked by the CBP Commissioner, an AC of an operational component or by the appropriate Responsible Official (RO). The authority to carry may also be temporarily revoked by a CBP supervisor.

2. Temporary revocations will be based on reliable evidence. Permanent revocations will be based on substantiated evidence.

3. Credentials may be temporarily or permanently revoked by the CBP Commissioner, AC of an operational component or the appropriate RO.

 a. The revocation of credentials results in the automatic revocation of the authorization to carry a CBP-issued firearm.

 b. The revocation of the authorization to carry a firearm does not automatically result in the revocation of credentials.

4. Situations that warrant the temporary or permanent revocation of the authority to carry firearms and/or credentials include (but are not limited to):

 a. The failure to demonstrate proficiency with firearm(s) or other mandatory training requirements without an authorized exemption;

 b. Medical conditions that impede the safe and effective use of a firearm. In such circumstances the Authorized Officers/Agents may have the authorization to carry a firearm temporarily revoked. A medical evaluation in accordance with regulations shall take place before a permanent revocation occurs;

 c. Evidence of substance abuse;

 d. Evidence of the commission of a felony;

 e. Evidence of (including an arrest or conviction for) the commission of an act of domestic violence (see Chapter 1.G) or the existence of a protective order related to acts of domestic violence (see Chapter 1.G.3);

 f. Evidence of unlawful violent behavior, or behavior that indicates that the individual may be a danger to themselves or others;

Issue #1–Re-identification of an Individual's Race and Ethnicity

The first part of the question asks whether or not an individual
is Hispanic/Latino.

While this part pertains to ethnicity, to avoid confusion
the word need not be mentioned.

The second part of the question asks an individual to select
one or more races from the following five groups:

American Indian or Alaska Native, Asian, Black or African American,
Native Hawaiian or Other Pacific Islander, and White.

Note that an alternative such as "some other races," or "race unknown"
is not an option.

- **Policy.05**
- Priority 1 (threats to national security, border security, and public fety)
- Q. Es necesario tener todo las documentos de identificación en regla.

g. Evidence of ~~serious~~ breaches of ~~CBP~~ integrity or
~~security policies;~~

h. Evidence of a credible threat to use a firearm in
an unlawful manner, and/or

i. ~~If an RO determines that the revocation is~~
in ~~the best~~ interests of ~~CBP and/or the officer/~~
~~agent. Such~~ authority ~~will be reasonably~~
~~exercised.~~

5. ~~When the authority to carry a CBP-issued firearm(s)~~
~~is temporarily revoked by a supervisor, the supervisor~~
shall (within 24 hours of such action) ~~:~~

~~a. Provide written notification to the~~
~~RO of the action~~ taken, ~~identifying the~~
~~officer/agent involved and documenting the~~
~~circumstances supporting the revocation~~
~~determination.~~

6. When the authority to carry a CBP-issued firearm
~~is~~ ████████████████████████████████████
with a written ~~notification~~ explaining:

a. The reason(s) for ~~the~~ revocation;

b. The nexus between ~~their~~ conduct ~~(performance~~
~~or condition)~~ and the threat to ~~the~~ safety of the
~~employee or others;~~

~~c. Any limitations on the performance of duties; and~~

~~d. The duration (or anticipated duration) of the~~
~~revocation. This written notification~~ will be
~~provided as soon as practicable.~~

7. ~~When the authority to carry a CBP-issued firearm is~~
████████████████████████████████████ Officers/
~~agents shall not perform duties or assignments that normally~~
~~require use of a firearm.~~

~~a. Permanent revocation~~ ████████████████
~~cred~~ ████████████████████████████████
████████████████████████ ~~as their issued~~
~~agency-wide CBP~~ ████████████

8. ~~If the revocation of a CBP-issued firearm(s) extends~~
~~beyond seventy-two (72) hours it shall be recorded in~~
the Firearms, Armor, and Credentials ~~Tracking System~~
(FACTS).

9. Authorized Officers/Agents whose authority to carry
a CBP-issued firearm has been temporarily revoked due
to any of the circumstances listed in Chapter 1.F.4
████████████ ~~suspended indefinitely, while under~~
~~investigation shall turn in all CBP-issued firearms and~~
~~ammunition to the appropriate coordinator.~~

G. Domestic Violence and the Authority to Carry Firearms

1. It is the responsibility of any armed CBP employee who is arrested for, or charged with, a crime of domestic violence to promptly report their arrest or charge to their immediate supervisor.

2. During the period pending disposition of the domestic violence case (following an arrest or charge for, and until the case has been resolved by the appropriate legal authority) CBP employees shall not be permitted to possess or carry any CBP-issued firearms or ammunition.

 a. The armed employee's supervisor shall ensure that the affected employee's

3. Protective Orders. For purposes of this Handbook, a protective order related to domestic violence shall be considered to be restraining order and therefore subject to the restrictions of subsection G.2 above if the order

 a. Was issued after a hearing of which such person had an opportunity to participate;

 b. Restrains such person from harassing, stalking, or threatening an intimate partner of such person or child of such intimate partner or person, or engaging in other conduct that would place an intimate partner in reasonable fear of bodily injury

 c. Includes a finding that such person represents a credible threat to the physical safety of such intimate partner or child; or by its terms explicitly prohibits the use, attempted use, or threatened use of physical force against such intimate partner or child that would reasonably be expected to cause bodily injury

4. Pursuant to 18 U.S.C. § 922(g)(9), it is illegal for anyone, including a federal law enforcement officer, who has been convicted of a misdemeanor crime of domestic violence to possess any firearm or ammunition.

H. Carriage of Personally-Owned Firearms Off-Duty

1. Nothing in this Handbook shall be construed as interfering with the rights that Authorized Officers/Agents may have as citizens to carry a personally-owned firearm off-duty for personal use. Authorized Officers/Agents must comply with all applicable federal, state and local laws when exercising any such rights.

2. Guidance on CBP policy regarding the off-duty carriage of personally-owned firearms may be found in the Commissioner's Handbook the Law Enforcement Officers Safety Act (LEOSA), dated August 13, 2013, attached as Appendix V.

Priority 1 (threats to national security, border security, and public safety)

Aliens engaged in or suspected of terrorism or espionage,
or who otherwise pose a danger to national security;

aliens apprehended at the border or ports of entry
while attempting to unlawfully enter the United States;

aliens convicted of an offense for which an element was active participation
in a criminal street gang;

aliens convicted of an offense classified as a felony in the convicting jurisdiction,
for which an essential element was the alien's immigration status; and

aliens convicted of an "aggravated felony," as that term is defined
in section 101(a)(43) of the Immigration and Nationality Act.

The removal of these aliens, must be prioritized.

Q. Es necesario tener todo las documentos de identificación en regla.

The correct answer is response D

because *todos los* is plural in number

 and masculine in gender, and is thus in agreement

with *documentos*. Responses A, B, and C

have either the wrong gender or the wrong number.

- **Policy.06**
- DEFINITIONS
- Lawful Permanent Residents

Chapter 2: Authorizing and Approving Officials

A. Responsible Officials (ROs)

1. A RO is responsible for the **implementation** of the CBP use **of force** program and for **ensuring compliance** with the CBP Use of Force Policy, Guidelines and Procedures Handbook by all Authorized Officers/Agents within his or her **area of responsibility**.

2. Each RO has **primary** responsibility for inventory **control**, maintenance, and security of all CBP use of force equipment within his or her area of responsibility.

3. Each RO shall designate a Firearms Coordinator (FCO) to manage the firearms and ammunition program within his or her area of responsibility (see Chapter 11). These designees are responsible for overseeing the shipment, receipt, issuance and the periodic inventory of use of force equipment.

4. The ROs are:

 a. Assistant Commissioners of CBP Operational Components (ACs), and the Chief, Office of Border Patrol (OBP);

 b. Chief Patrol Agents (CPA);

 c. Directors, Field Operations (DFO);

 d. Directors, Air Operations and Marine Operations (DAO, DMO);

 e. Division Directors, Internal Affairs (IA);

 f. Division Directors, Office of Training and Development (OTD); and

 g. Other officials designated in writing by the Commissioner.

B. The Director of the Use of Force Center of Excellence (UFCE)

1. The Director of UFCE has primary responsibility to:

 a. Direct all aspects of the CBP use of force and firearms program, including less-lethal equipment;

 b. Direct the development and implementation of CBP use of force and firearms policies and procedures;

c. Direct the technical and evaluation aspects of the CBP use of force and firearms programs;

d. Direct the development of the training curriculum and the training of CBP firearms instructors, armorers, less-lethal instructors and other related training;

e. Direct the review of field use of force training and training programs;

f. Direct the review of use of force incidents, in order to review and/or improve CBP training, tactics, policy and equipment;

g. Direct the collection and storage of qualification and instructor certification records;

h. Establish the procedures for the selection, training, and certification of armorers, firearms instructors, less-lethal instructors, and other advanced instructors;

i. Oversee all CBP armories and direct the maintenance, repair, and alteration of all CBP-issued and authorized firearms;

j. Oversee the control and accountability of all firearms, ammunition, ordnance, less-lethal devices and body armor; and

k. Maintain a list of authorized weapons, holsters, ammunition, equipment and accessories.

1. The Director of UFCE is responsible for overseeing the acquisition of all CBP- issued firearms, ammunition, ordnance, less-lethal equipment and body armor.

2. No CBP component or individual officer/agent or employee is authorized to solicit, accept or otherwise acquire or dispose of CBP-issued firearms, or other use of force equipment that is accountable in the Firearms, Armor and Credentials Tracking System (FACTS), outside of authorized CBP equipment procurement and distribution procedures for any CBP purpose or operation without the written consent of the Director of UFCE.

C. The UFCE Incident Review Committee

1. The UFCE Incident Review Committee is authorized to review any incident in which use of force is employed, whether by a CBP employee or directed at an employee.

a. Any use of deadly force by a CBP employee against a person shall be reviewed by the Committee.

2. The primary role of this Committee is to allow qualified experts an opportunity to perform an internal analysis of these incidents from a perspective of training, tactics, policy and equipment. Accordingly, this Committee will not make any recommendations concerning **disciplinary** or adverse **action**s.

3. Through a **deliberative process**, the Committee will identify trends that may impact **the** use of force procedures and **policies employed** by CBP **to protect** its personnel, **property and operations**.

4. The UFCE Incident Review Committee members are:

 a. The Director of UFCE, who serves as committee chair; and

 b. Designated representative(s) from each CBP operational component.

5. The UFCE Incident Review Committee shall meet on a quarterly basis, and additionally at the discretion of the Director of UFCE when sufficient use of force incident data is assembled to warrant the convening of the Committee.

6. Quarterly, the Committee shall submit a report outlining findings and recommendations, as appropriate, to the CBP Commissioner.

DEFINITIONS

In this section: The term "person"

means any natural person or any corporation,

company, firm, partnership, joint stock company or association

 or other organization or entity (whether organized under law

or not).

 The term "worker" means an individual

who is the subject

 of foreign labor contracting activity.

Lawful Permanent Residents

As a legal matter, LPRs, although allowed to stay and work

in the United States permanently, are still "aliens,"

their status can be rescinded, they can be removed.

LPRs are required to acquire, and carry evidence of their status,

they must present specific documentation

as a condition for admission and re-admission, must notify

DHS of each change of address,

may be deemed to have abandoned their status

when outside of the United States for more than one year,

unless they obtain a re-entry permit.

LPRs must apply for naturalization to obtain citizenship, demonstrating

good moral character,

and at least five years of continuous residence,

as well as an understanding of the English language

and a knowledge and understanding of the fundamentals

of the history, principles, and form of government of the United States.

These requirements, and others, clearly differentiate them

from United States citizens.

- **Policy.07**
- A Less Lethal Launcher

A. Responsibilities Following a Use of Deadly Force

1. Any use of deadly force shall be orally reported to a CBP supervisor:

a. Unless the employee is physically incapacitated or otherwise unable, the report shall be made within one hour of the time the incident occurs.

The report shall be made either in person, or via radio or telephone, and shall be comprised of the following information (if known):

(1) The date, time, and location of the incident;

(2) The identity and current location of any injured or deceased person(s), an assessment of the extent of their injuries and whether medical assistance has been requested;

(3) The identity, physical description, and current location of any individual(s) known to be involved in, or to have witnessed the incident, including subjects who are at large;

(4) The description and location of conveyances involved in the incident, including any subject conveyance(s);

(5) A brief description of the incident, including any information that might cause additional conflicts or confrontations;

(6) The operational activity in which the Authorized Officer/Agent or employee(s) involved in the incident was engaged;

(7) When firearms are used, the type of firearm(s), the number of shots fired, and the current location of all firearms used in the incident;

(8) Any other information that is needed to assure that the operational responsibilities of CBP related to the security of human life and CBP equipment are properly carried out.

2. Any Authorized Officer/Agent who observes or becomes aware of a use of deadly force, and has a reasonable belief that the incident has not yet been reported, shall orally report the incident to a supervisor as soon as practicable.

3. Following the initial reporting of the incident, an employee who learns of additional information concerning the items listed in Chapter 1 shall, as soon as practicable, make an oral report of such information to a supervisor.

A CBP supervisor, upon notification of a use of deadly force, a supervisor shall:

a. Secure the incident scene, and seek medical assistance for any person who appears, or claims to be, injured;

b. Ensure that all CBP employees who were involved in the incident have been identified and advised that they will be interviewed by investigative personnel and that they are to remain on duty until released;

c. Make an initial report via established chain of command;

 (1) The initial supervisory report shall contain a summary of the incident and shall be made within one hour of receipt of the first employee report

 (2) The report shall be made through official channels, but the report shall not be delayed when observance of the chain of command is impractical.

d. Report the incident to CBP HQ via the Commissioner's Situation Room in accordance with CBP Directive ___-025D (or any successor policy);

e. Notify the Office of Internal Affairs via the Joint Intake Center (JIC), and via notification to the duty agent of the specific IA regional office with responsibility for that area of operations;

f. Notify the Office of Human Resources Drug Program Coordinator;

g. Assume the scene responsibility for media contacts. Supervisors should _____ assistance from their public affairs officer. Media should be provided reasonable access to the scene, with preservation of evidence and efficient operations determining the limits of reasonable access;

h. _____

i. Report the use of force in the CBP Use of Force Reporting System on CBPnet. Initial reports should be submitted/completed in the system within 72 hours.

Supervisors, line supervisors, and/or investigators are aware that if an employee who used force, one of the is prohibited from making a written statement regarding the incident. Other CBP personnel _____ may be _____ a written statement regarding the incident;

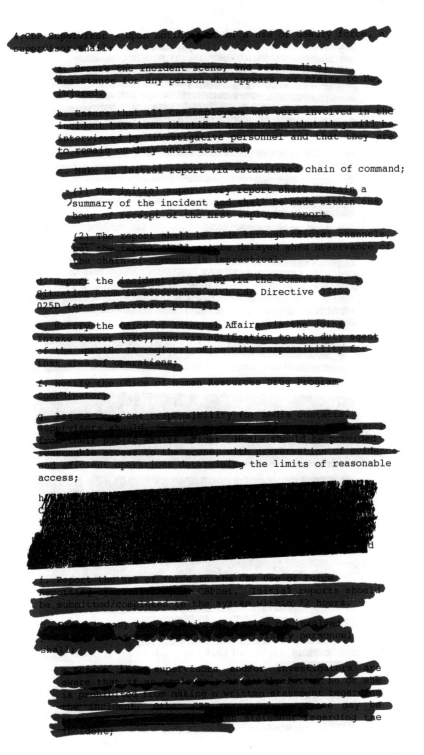

b. ~~Ensure that when any~~ bargaining unit ~~employee~~ ~~is~~ compelled by or through ~~CBP and/or DHS to provide~~ ~~any information that could reasonably lead to~~ ~~disciplinary action against that employee (other than~~ ~~the initial verbal notification outlined herein), he~~ ~~or she is advised in writing of his or her right to~~ ~~union representation in accordance with the applicable~~ ~~provisions of the law and governing Collective~~ ~~Bargaining Agreement;~~

c. ~~Ensure that supervisory or investigative officers~~ ~~involved in~~ the ~~investigation of a use of force incident~~ ~~are aware that any information provided by any employee~~ ~~under~~ threat of disciplinary action ~~by CBP, or compelled~~ ~~by any other means, may be subject to exclusion from~~ ~~criminal proceedings consistent with the standards~~ ~~outlined in Garrity v. New Jersey, 385 U.S. 493 (1966);~~

d. ~~In appropriate circumstances, and upon proper~~ ~~authorization, employees will be provided "Kalkines"~~ ~~warnings consistent with Kalkines v. U.S., 473 F.2d~~ ~~1391 (Ct. Cl 1973) informing them of the~~ requirement to cooperate ~~in management's examination when the employee~~ ~~has been assured that he or she will not be subject to~~ ~~criminal action;~~

~~(1) After~~ ~~appropriate circumstances,~~ es, an employee's ~~conduct~~ ~~personnel or administrative~~ ~~investigation may result in disciplinary action up to~~ ~~and including removal.~~

e. [redacted]

[redacted]

~~6. Responsible Officials (ROs) - Upon~~ notification of a use ~~of deadly force, the RO (or his or her designee) shall:~~

a. ~~Ensure that~~ the ~~incident~~ scene ~~(and~~ all relevant ~~evidence) are secured, and that medical attention is~~ ~~provided for any individual injured;~~

b. ~~Ensure that information regarding the deadly force~~ ~~incident is~~ collected ~~and~~ reported in accordance ~~with~~ ~~Chapter 3.A.1;~~

c. ~~Ensure that the incident has~~ been reported to the law ~~enforcement authorities having jurisdiction over the~~ ~~investigation and that they have~~ been advised of CBP's ~~desire to maintain its role during the investigation;~~

e. Until the incident is resolved, one is still
~~be responsible for responding to requests for~~
~~information about the incident from the public, the~~
~~media, and other agencies with a need to know,~~
~~after coordinating such information release with the~~
Chief of Public Affairs; and

f. Following the initial report of the incident and
during the ensuing investigation, ~~the RO shall ensure~~
~~that copies of all investigative reports, any other~~
~~pertinent documentation, copies of all printed and~~
~~televised media reports are provided through chain of~~
~~command;~~

~~7. All use of force incidents involving CBP personnel~~
~~shall be reported via the established chain of command in~~
the geographic jurisdiction where the incident occurred.

8. Following the submission of the initial supervisory
report, any supervisor or other CBP management official
who receives additional information regarding the incident
shall, as soon as practicable,
to CBP's Law Enforcement Coordination Center/Watch Room in
accordance with CBP Directive 3340- 025D (or any successor
policy).

9. If any CBP employee becomes aware of apparent misconduct
or violation of CBP policy regarding the use of force, that
employee shall notify the Office of Internal Affairs via the
Joint Intake Center (JIC).

B. Reporting the Discharge of a Firearm

1. Authorized Officers/Agents (and other armed CBP
employees) must report the following firearms discharges:

a. Any discharge of a CBP-issued firearm (including
unintentional discharges) except for intentional
discharges which occur during firearms training, practice,
or qualification, and do not cause any injury to a person
or animal, or unintentional damage to private, public,
or government property; or

b. A discharge of any firearm that:

(1) is in violation of any law or ordinance, or
causes an investigation by any law enforcement
agency;

(2) is, or reasonably appears to be, discharged in an
unsafe or reckless manner, due to impairment caused by
the consumption of alcohol or drugs;

(3) Is an act of assault against any Authorized officer/Agent, or employee, and the assault is, or reasonably appears to be, related to his or her CBP employment; or

(4) Is a discharge of a firearm by a law enforcement officer other than an Authorized officer/Agent, when the discharge occurs during multi-agency operations involving CBP personnel.

Any reportable discharge not involving the use of deadly force shall be reported through the chain of command and through the Use of Force Reporting System (UFRS) on CBPnet. Initial reports should be submitted/completed in the system within 72 hours.

a. At the discretion of the RO, a local investigation/review (consistent with the requirements of Chapter 5) may ▮▮▮▮▮▮▮▮▮

▮▮▮▮▮▮▮▮▮▮▮▮▮▮▮▮▮▮▮▮▮▮▮▮▮▮▮▮

To send a firearm to the UFCE facility, ensure that the firearm and magazine are unloaded and that they have NOT been cleaned or disassembled prior to shipping.

When an employee is required to relinquish his or her CBP-issued firearm, but the authority to carry a firearm has not been revoked, he or she shall promptly be provided with:

a. A replacement CBP issued firearm; and

b. The opportunity to familiarize himself or herself with the replacement firearm under the supervision of a Firearms Instructor (FI).

The employee shall qualify with the replacement firearm as soon as practicable.

A shooter-induced unintentional discharge for which the employee acknowledges responsibility, does not require the firearm be sent to the UFCE facility.

Post-incident safety and function remedial training ▮▮▮▮▮▮▮▮▮▮▮▮▮▮▮▮▮▮ documented by the local FI. The ▮▮▮▮▮▮▮▮▮▮▮ shall be included in the incident investigation file.

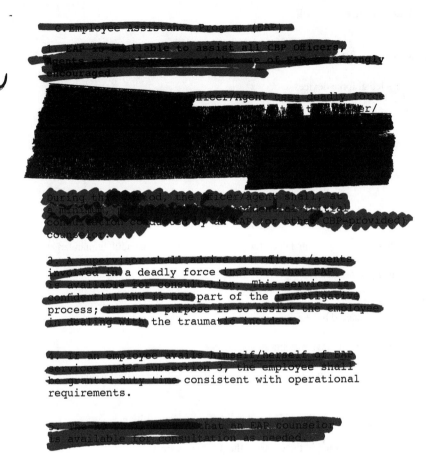

During the period, the officer/agent shall, at a minimum, confidential consultation with an EAP (or other CBP-provided) counselor.

2. A supervisor shall advise all officers/agents involved in a deadly force incident that EAP is available for consultation. This service is confidential and is not part of the investigative process; its sole purpose is to assist the employee in dealing with the traumatic incident

4. If an employee avails himself/herself of EAP services under subsection 3, the employee shall be granted duty time consistent with operational requirements.

5. The department ensure that an EAP counselor is available for consultation as needed.

A Less Lethal Launcher

We are replenishing, upgrading, expanding our fielding

of less lethal force devices.

We would consider equipment

comparable in form, in quality, and munitions delivery

to our current arsenal.

The launcher must be magazine fed, accurately fire projectiles

so that a reasonably trained operator can acquire an adult human target

effectively at 50 meters.

It should have a durable exterior, of metal, or polymer,

or similar material that presents an appearance

associated with law enforcement and military tactical weaponry.

Live chemical rounds should immediately affect ocular swelling

and burning sensation in the eyes and the respiratory tract.

The chemical must be a product tested by federal law enforcement,

and currently in use for the control of resistant, combative,

and fleeing subjects.

70

- **Policy.08**
- Responsabilidades

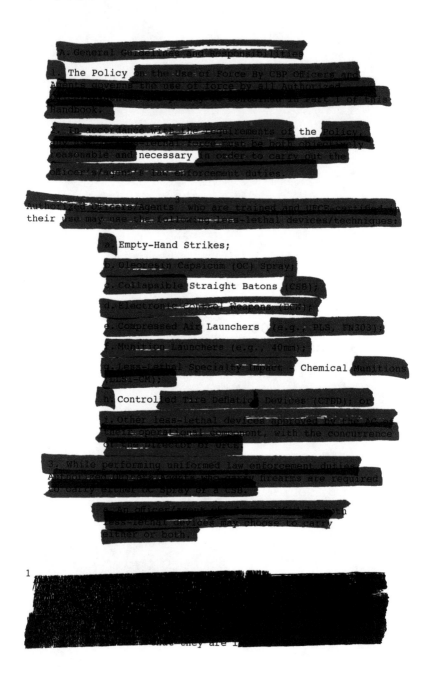

A. General Guidelines and Responsibilities

1. The Policy on the Use of Force By CBP Officers And Agents governs the use of force by all Authorized ██ Part 1 of this Handbook.

2. In accordance with the requirements of the Policy, ████████████████████████████████ be both objectively reasonable and necessary in order to carry out the officer's/agent's law enforcement duties.

Authorized Officers/Agents² who are trained and UFCE-certified in their use may use the following less-lethal devices/techniques:

 a. Empty-Hand Strikes;

 b. Oleoresin Capsicum (OC) Spray;

 c. Collapsible Straight Batons (CSB);

 d. Electronic Control Weapons (ECW);

 e. Compressed Air Launchers (e.g., PLS, FN303);

 f. Munition Launchers (e.g., 40mm);

 g. Less-Lethal Specialty Impact - Chemical Munitions (LLSI-CM);

 h. Controlled Tire Deflation Devices (CTDD); or

 i. Other less-lethal devices approved by the AC or their operational component, with the concurrence of the Director of UFCE.

3. While performing uniformed law enforcement duties, ████████████████████████████████ firearms are required to carry either OC spray or a CSB.

████ An officer/agent ████████████████████████ both less-lethal devices may choose to carry either or both.

1 ███
███
███
████████████ they are ███

b. An officer/agent who is only certified in ~~less-lethal device shall carry only that device.~~

~~require that all~~ ~~a each~~ ~~addition~~ less-lethal devices (that they are certified ~~while performing specified uniformed law enforcement duties.~~

B. Reporting the Use of Less-Lethal Force

1. Authorized Officers/Agents - Authorized Officers/Agents shall report all incident involving the use of less- ~~serious physical injury or death) by:~~

the report shall be ~~the radio~~ ~~shall be comprised of the following information if known:~~

(1) The date, the time and the location of the incident.

(2) The less-lethal device(s) used by the officer/agent and subject;

(3) The nature and the extent of any injuries claimed or observed and whether medical assistance has been requested; and

(4) The name, date of birth, and physical location of the subject(s)

(1) The memorandum shall describe in detail the circumstances of the incident, including the actions of the subject necessitating the use of force and the specific force used ~~injuries or complaint of injuries, and any~~ ~~or refusal of medical treatment, shall be documented.~~

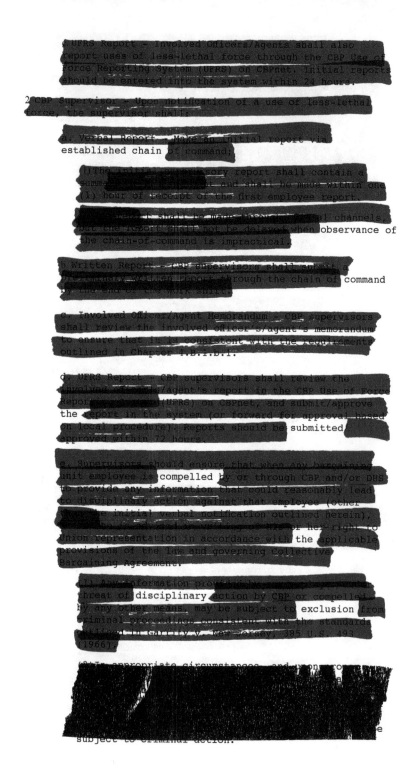

c. UFRS Report - Involved Officers/Agents shall also report uses of less-lethal force through the CBP Use of Force Reporting System (UFRS) on CBPnet. Initial reports should be entered into the system within 24 hours.

2. CBP Supervisor - Upon notification of a use of less-lethal force, the supervisor shall:

a. Verbal Report - Make an initial report via established chain of command.

(1) The initial supervisory report shall contain a summary of the incident and shall be made within one (1) hour of receipt of the first employee report.

(2) The report shall be made through normal channels, but the report shall not be delayed when observance of the chain-of-command is impractical.

b. Written Report - CBP supervisors shall submit a preliminary written report through the chain of command by the end of the work shift.

c. Involved Officer/Agent Memorandum - CBP supervisors shall review the involved officer's/agent's memorandum to ensure that it is consistent with the requirements outlined in Chapter 1.B.1.b.1.

d. UFRS Report - CBP supervisors shall review the involved officer's/agent's report in the CBP Use of Force Reporting System (UFRS) on CBPnet, and submit/approve the report in the system (or forward for approval based on local procedure). Reports should be submitted/approved within 72 hours.

e. Supervisors should ensure that when any bargaining unit employee is compelled by or through CBP and/or DHS to provide any information that could reasonably lead to disciplinary action against that employee (other than the initial verbal notification outlined herein), he/she is advised of his or her right to Union representation in accordance with the applicable provisions of the law and governing Collective Bargaining Agreement.

(1) Any information provided under the threat of disciplinary action by CBP or compelled by any other means, may be subject to exclusion from criminal proceedings consistent with the standards outlined in Garrity v. New Jersey, 385 U.S. 493 (1966).

(2) In appropriate circumstances, and upon consultation with the employee subject to criminal action.

After ████████ ████ ████████ an employee's
failure ██ ████████ ██ ██ ████████████
investigation ███ ██████ ████████████ ████ ██████ up to
and including removal.

██ If any CBP employee becomes aware of apparent misconduct
or **violation** of CBP ██████ regarding the use of force, that
employee shall ██████ ████████ ████████ Affairs via the
Joint Intake Center (JIC).

4 ██
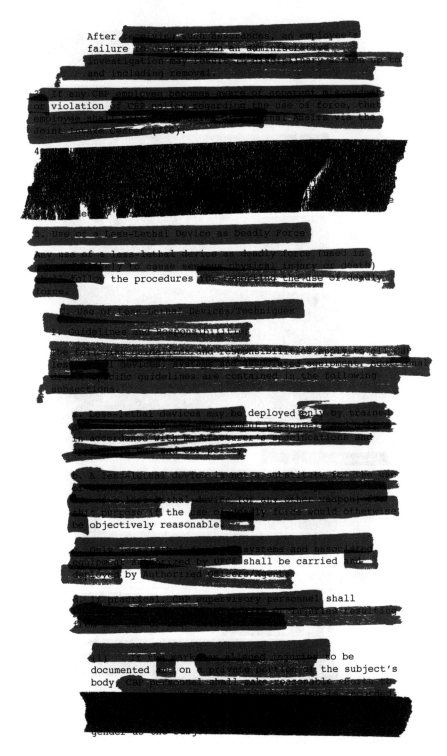

5. Use of a Less-Lethal Device as Deadly Force

Any use of a less-lethal device as deadly force (used in
████████████ly to cause serious physical injury or death)
████ follow the procedures ███ ████████ the use of deadly
force.

██ Use of Less-Lethal Devices/Techniques

1. Guidelines ███ Responsibilities

The ████████ guidelines and responsibilities apply to all CBP
less-████████ devices, ████████ and ████████ equipment. Additional
███████ specific guidelines are contained in the following
subsections.

██ Less-lethal devices may be deployed only by trained
███████████ ███ █████████ personnel ████████
in accordance with manufacturer's specifications and
███████████ ████████ policy.

██ A less-lethal device is not a substitute for the use
of ███████████████████████████████████████
███████ less-lethal device (or any other weapon) ████
this purpose if the use of deadly force would otherwise
be **objectively reasonable** ████

██ ████████ ████████ systems and associated
equipment authorized by UFCP shall be carried and
deployed by Authorized Officers/Agents.

██ If practical, CBP supervisory personnel shall
███████████████████████████████ injuries resulting
fr█████████████████████████████████████

██ If the ████ alleged injuries to be
documented are on ██ private portions of the subject's
body, CBP personnel shall make reasonable efforts to
██
gender as the subj████████████████████████████████

e. Less-lethal devices, systems and associated equipment shall not be altered in any way without the written authorization of the Director of UFCE.

f. UFCE shall be responsible for development and approval of less-lethal device training materials and certification standards.

g. Authorized Officers/Agents are responsible for the general care and safeguarding of the less-lethal devices and equipment issued to them, and may be subject to disciplinary action for any loss or damage resulting from negligence by the officer/agent.

h.

i.

j.

2. Empty-Hand Strikes

a. Strikes targeting strike pressure points may be utilized as a compliance tool on a subject offering, at a minimum, active resistance.

b. Other strikes (e.g., punches, kicks, etc.) may be utilized as a defensive tactic on a subject offering, at a minimum, assaultive resistance.

3. Oleoresin Capsicum (OC) Spray

a. OC Spray may be utilized as a compliance tool on a subject offering, at a minimum, active resistance.

b. Authorized Officers/Agents may only use chemical agents authorized by the Director of UFCE. Officers/agents may not carry personally-owned OC devices for duty use.

c. Authorized Officers/Agents shall decontaminate exposed subject(s) as soon as practicable.

d. Authorized Officers/Agents are responsible for advising their supervisors when the devices issued to them are approaching the end of their useable life so that they can be replaced prior to their expiration date.

e. Authorized Officers/Agents are required to turn in expired, damaged, or empty OC spray canisters to local training staff for proper disposal in accordance with local Environmental Protection Agency (EPA) and Occupational Safety and Health Administration (OSHA) requirements.

f. The TSA and FAA do not permit any chemical agents in the cabin of a commercial aircraft. As provided by 49 C.F.R. § 175.10, self-defense spray (mace or pepper spray) may be carried in checked baggage, provided the container does not exceed four fluid ounces and has a positive means to prevent accidental discharge. Chemical agents shall be carried aboard CBP aircraft only in accordance with *CBP Air Operations Handbook* (AOH) guidelines.

3. Collapsible Straight Batons (CSB)

a. A CSB may be utilized as a defensive tool on a subject offering, at a minimum, assaultive resistance.

b. Authorized Officers/Agents may only use CSBs authorized by the Director of UFCE. Officers/Agents may not carry personally-owned batons for duty use.

c. The following acts and techniques with the CSB are prohibited when using less-lethal force:

(1) Choke holds, carotid control holds, and other neck restraints;

(2) Use of a baton to apply "come-along" holds to the neck area; and

(3) Intentional strikes with the baton to the head, the neck, the face, the groin, the solar plexus, the kidneys or the spinal column.

4. Electronic Control Weapons (ECWs)

An ECW is a less-lethal weapon which is designed to use short-duration electronic pulses to cause Neuro-Muscular Incapacitation (NMI) and/or pain, with minimal risk of serious physical injury or death.

b. An ECW should be deployed for one standard cycle (five seconds) and then evaluate the situation to determine if subsequent cycles are reasonable and necessary. Each ECW cycle must be both reasonable and necessary to overcome non-compliance by an actively resistant subject and to accomplish the officer/agent's law enforcement duties

(1) Authorized Officers/Agents should use an ECW on a subject who is running only when the officer/agent has reasonable belief that the subject presents an imminent threat of injury to an officer/agent or another person. The threat presented by the subject must outweigh the risk of injury to the subject that might occur as a result of an uncontrolled fall while the subject is running.

c. Authorized Officers/Agents should not intentionally expose a subject to more than one ECW at a time.

d. Authorized Officers/Agents shall not intentionally target the head, neck, groin or female breast.

e. When practicable and when other Authorized Officers/Agents are present, officers/agents should verbalize "TASER, TASER, TASER" prior to deployment to warn fellow officers/agents of the imminent use of an ECW. This will alert fellow officers/agents to prepare to control a subject under the power of an ECW.

f. ECWs shall be carried on the non-gun side in ECW-authorized holster issued by CBP or purchased through an official uniform purchase program.

g. Any subject in CBP custody who has been exposed to an ECW shall, as soon as practicable, be seen by an emergency Medical Technician or other trained medical professional.

h. CBP personnel trained and certified in the use of an ECW may remove probes embedded in a person's skin, provided the probes are not embedded in a sensitive area like the head, neck, genitals, or female breast tissue.

Probe removals in those instances shall be performed by a trained medical professional.

k. ECW probes are considered a biohazard and shall be disposed of according to established biohazard disposal protocol.

██
██
██

m. After ████████████████████████████████
██
████████████ (CEW).

6. Compressed Air Launchers (e.g. PLS and FN303)

Compressed air launchers are less-lethal impact/chemical irritant delivery systems that are powered by compressed air. These launchers can deliver a variety of less-lethal projectiles including kinetic impact, PAVA, pepper powder and non-toxic marking rounds.

a. A compressed air launcher may be used for area saturation against subject(s) who, at a minimum, demonstrate active resistance.

b. A compressed air launcher may be used as a chemical irritant delivery system on subject(s) who, at a minimum, demonstrate assaultive resistance.

c. Authorized Officers/Agents may also use a PLS to remove subjects who are intentionally covering the mouth of a vessel in order to deploy marine disabling fire. Such deployment must target the strike pressure points of the outer extremities (i.e., arms and legs).

d. Authorized Officers/Agents may use a compressed air launcher to mark a conveyance for identification purposes in situations where a conveyance has failed to comply with another officer's/agent's lawful attempt to stop it, in situations where the use of a controlled tire deflation device would not be reasonable, or if an involved vehicle is leaving the scene of an enforcement action without authorization. When deploying a compressed air launcher for marking and identification purposes, officers/agents may not target the conveyance windows.

e. Authorized Officers/Agents should not use a compressed air launcher, and should consider other force options, on subjects who are: small children; elderly; pregnant; or operating a conveyance.

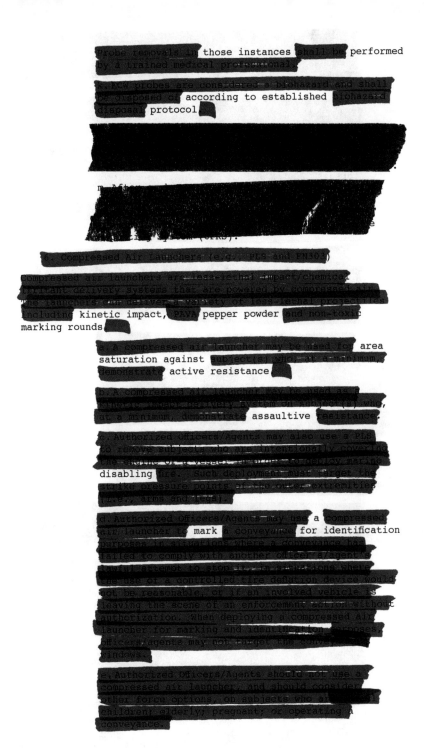

g. Authorized Officers/Agents may use the FN303 on subjects between 10 to 225 feet away as a kinetic impact device. Officers/agents engaging subjects with the FN303 from 10 to 20 feet should target the subject's lower extremities. Officers/agents engaging subjects greater than 20 feet may target the lower torso, or upper and lower extremities (i.e. arms and legs).

h. The FN303 shall not be deployed if the officer/agent is less than 10 feet from the subject unless the use of deadly force is reasonable and necessary.

i. The intentional targeting of areas where there is a substantial risk of serious physical injury or death is considered a use of deadly force. Authorized Officers/Agents shall not intentionally target the head, neck, spine, or groin of the intended subject, unless the use of deadly force is reasonable.

Munition Launchers (e.g., 40mm) and Less-Lethal Specialty Impact and Chemical Munitions (LLSI-CM)

Munition Launchers are a less-lethal specialty impact/chemical munition (LLSI-CM) delivery system that are designed to deliver an impact projectile, a chemical irritant projectile or a combination projectile with more accuracy, higher velocity, and longer range than a projectile deployed by hand.

LLSI-CM can also be delivered by means of a device that is designed to be hand thrown by an Authorized Officer/Agent.

a. Subject to the exceptions described in subsection c. below, a Less-Lethal Chemical Munition (LLCM) may be utilized as a compliance tool on a subject offering, at a minimum, active resistance.

b. Subject to the exceptions described in subsection c below, a Less-Lethal Specialty Impact (LLSI) munition may be utilized as a compliance tool on a subject offering, at a minimum, assaultive resistance.

c. Authorized Officers/Agents should not use a LLSI-CM and should consider other force options with respect to subjects who are: small children; elderly; pregnant; near known flammable materials (when using a pyrotechnic device); or operating conveyances.

d. When practicable and when other officers are present, Authorized Officers/Agents should verbalize "Less-Lethal, Less-Lethal, Less-Lethal" prior to deployment to warn fellow officers/agents of the imminent use of a LLSI-CM. This will alert fellow officers/agents to prepare for the deployment of a LLSI-CM.

e. Authorized Officers/Agents shall not intentionally target the head, neck, groin or female breast.

f. Any subject in CBP custody who has been exposed to a LLSI-CM shall, as soon as practicable, be seen by an emergency Medical Technician or other trained medical professional.

g. The Federal Aviation Administration (FAA) ~~prohibits the transportation of LLCM's and/or LLSI-CM combinations (e.g., CS (O-Chlorobenzylidene-malononitrile dispersal)) onboard commercial aircraft.~~ All CBP employees will comply with this regulation. Transportation of LLSI-CM munitions will be accomplished by the use of a CBP vehicle/vessel and/or an authorized commercial ground carrier.

h. The transportation of LLSI-CM onboard CBP vessels must conform with the appropriate safety standards such as storage and transportation of the devices in insulated, water proof containers to prevent damage or unintended discharge.

i. Once the safety pin has been pulled on a hand-held LLSI-CM the deployment of the hand-held LLSI-CM should be immediate. The safety pin should never be reinserted in the hand-held LLSI-CM once it has been pulled.

j. Approval from the Director of UFCE is required prior to each individual purchase of LLSI-CM.

7. Controlled Tire Deflation Devices (CTDDs)

CTDDs are specialized devices whose deployment results in the controlled deflation of a vehicle tire.

a. A CTDD may only be deployed with supervisory authorization and when the immediate or potential danger to the public created by the deployment of the CTDD is less than the immediate or potential danger to the public should the suspect vehicle be allowed to proceed without deployment of the CTDD.

(1) The CTDD shall be deployed in a manner that minimizes risk of injury to persons or damage to property.

b. A CTDD may be deployed:

Responsabilidades

Apoyar y defender la Constitución.

Permanecer informado de las cuestiones que afectan a su comunidad.

Participar en el proceso democrático.

Respetar y obedecer a las leyes federales, estatales y locales.

Respetar los derechos, creencias y opiniones de los demás.

Participar en su comunidad local.

Perseguir los ideales de la Constitución, que incluyen *la vida, la libertad y la búsqueda de la felicidad.*

Pagar la renta, los impuestos federales, locales y estatales de manera honesta y siempre a tiempo.

Servir en un jurado cuando se le solicite.

Defender el país cuando se presente la necesidad.

- ~~Policy.09~~
- Glossary: Second Monday, October

(3) When a vehicle unlawfully crosses the border between POEs;

(4) When an Authorized Officer/Agent, acting within the guidelines set forth in this *Handbook*, is trying to prevent a suspect vehicle from leaving the area where a warrant is being served or where officers/agents have determined, or developed at least reasonable suspicion that a crime is being or may have been committed;

(5) When the configuration at permanent checkpoints allows for the safe deployment of the CTDD to prevent vehicles from avoiding inspection; or

(6) When another law enforcement agency requests deployment of the CTDD in an emergency. Supervisory approval is required unless exigent circumstances can be articulated. At checkpoints, supervisory authorization may be granted in advance for specific situations involving other law enforcement agencies.

b. The road where an Authorized Officer/Agent is considering the deployment of a CTDD should provide an unimpeded view of vehicular traffic from all directions. The CTDD may be used only in areas where topography, roadway surfaces, and vehicular conditions indicate that deployment can be accomplished with reasonable safety.

c. The Authorized Officer/Agent who deploys the CTDD should:

(1) During deployment of a CTDD, remain in visual contact and control of the CTDD unless the deploying officer/agent can articulate why visual contact and control are not safe and/or practical;

(2) Prior to deploying the CTDD, ensure that all CBP and other agency personnel involved are notified of the pending deployment of the CTDD via available communication methods. Communication shall be maintained between officers/agents in the deployment area unless exigent circumstances preclude such communication;

(3) Remove or deactivate the CTDD before becoming involved in the apprehension of the subject(s) unless exigent circumstances preclude such removal or deactivation; and

(4) Remember that safety is paramount. The officer/agent retains the discretion not to deploy the CTDD and should not do so if safety concerns are an issue.

d. Authorized Officers/Agents shall not deploy a CTDD in school zones when children are present or traveling to or from the school, or in cases when the danger to the public outweighs the enforcement benefit.

f. With the exception of Authorized Officers/Agents conducting enforcement operations on CBP aircraft, an officer/agent shall not overtake a pursued vehicle in order to deploy a CTDD.

g. Authorized Officers/Agents shall not deploy a CTDD to stop the following types of vehicles, except where an immediate danger to life makes it reasonable to deploy the CTDD: two or three-wheeled vehicles; vehicles known or reasonably believed to be transporting hazardous materials; or vehicles that there is a reason to believe would pose an unusual hazard to officers/agents or the public.

h. When a CTDD causes unintentional damage to a vehicle:

(1) The involved officer/agent will immediately report the incident to the duty supervisor;

(2) The duty supervisor shall provide a tort claim form (SF-95) to the driver of the vehicle for the damages to the vehicle that may have been caused by the CTDD along with instructions on how to complete the form and where to send the claim;

(3) In cases when the vehicle is rendered immobile, procedures must be in place to assist the driver in making the vehicle mobile; and

(4) The officer/agent involved in the incident shall document the incident in accordance with operational protocols. The incident report shall describe exactly what transpired and provide details of any assistance rendered to the driver.

9. Controlled Noise and Light Distraction Devices (CNLDDs)

A CNLDD is a pyrotechnic device that, once activated, emits a bright light and loud noise to momentarily disorient and confuse subjects; giving officers/agents a brief tactical advantage so they can bring the situation to a successful law enforcement resolution.

a. The pre-planned use of a CNLDD during law enforcement operations requires the approval of a Supervisor or Team Leader. In exigent circumstances, a CNLDD may be deployed without prior supervisory approval.

b. When practicable and when other Authorized Officers/Agents are present, officers/agents should verbalize "BANG OUT" prior to deployment to warn fellow officers/agents of the imminent use of a CNLDD.

c. The Supervisor or Team Leader shall ensure that all officers/agents wear appropriate personal protective equipment during any operation utilizing CNLDDs (see specific Operational Order for required equipment).

d. The Supervisor or Team Leader shall (when it is reasonably anticipated that CNLDDs will be employed and where practical) have a standard vehicle fire extinguisher (or larger) and appropriate medical equipment available at the scene or at a location nearby.

e. Once the safety pin has been pulled on a CNLDD the deployment of the hand held CNLDD should be immediate. The safety pin should never be reinserted into the hand held CNLDD once it has been pulled.

f. CNLDDs that have malfunctioned should be disposed of according to manufacturer's recommendations.

g. Authorized Officers/Agents should not use a CNLDD, and should consider other force options, with respect to subjects who are: small children; elderly; pregnant; or near known flammable materials.

h. Environmental considerations should be evaluated prior to deployment of a CNLDD.

i. Responsible supervisory personnel must ensure that ATF regulations and guidelines are known and followed by all subordinate personnel involved in the handling, storage, or use of these items.

j. The RO (or his or her designee) shall ensure that CNLDDs are only issued to trained and certified officers/agents with an articulated need for a CNLDD.

k. The issuance of CNLDDs shall be recorded on a CBP Form 259 signed by appropriate supervisory or authorized issuing personnel indicating the amount and type of CNLDD issued, record serial numbers, and to whom received them and for what reason. The receiving party will countersign the CBP Form 259.

l. The RO (or designee) shall maintain the CBP Form 259s in a folder (electronic or paper) for a period of not less than two years.

m. Responsible supervisory personnel shall maintain a written log regarding the operational and training use of CNLDDs. This log shall include the following information: how many CNLDDs were utilized; to whom they were issued; the serial number(s) of the CNLDDs; and how they were utilized (training or operations). This log will be periodically reviewed by the RO (or designee) to ensure compliance.

n. Approval from the Director of UFCE is required prior to each individual purchase of CNLDDs.

D. Warning Shots and Disabling Fire

1. Warning Shots - Warning shots are not permitted except as follows:

 a. Warning shots may be used by Authorized Officers/Agents when conducting maritime law enforcement operations only as a signal to stop a vessel.

 b. Warning shots may be used by Authorized Officers/Agents when conducting aviation law enforcement operations only as a signal to an aircraft to change course and follow direction to leave airspace.

Warning shots are to be used as a signal only. They are used to attract attention after all other available means of signaling have failed. This conforms to United States and international law, which recognize warning shots across the bow of vessels, or across the nose of an aircraft, as legitimate signals.

2. Disabling Fire - Firearms may not be used solely to disable moving vehicles, vessels, aircraft or other conveyances, except when Authorized Officers/Agents are conducting maritime law enforcement activities against maritime conveyances.

 a. When a pursued vessel fails to comply with an order to stop, and warning shots have been deployed, the CBP Vessel or Aircraft Commander may elect to authorize disabling fire.

 b. The authority to commence disabling fire rests with the Vessel or Aircraft Commander. The decision to fire, however, ultimately rests with the shooter. It is the shooter's responsibility to ensure the safe deployment of the disabling rounds.

3. Warning shots and disabling fire shall be deployed with strict adherence to UFCE-approved programs, policies, procedures and directives.

4. Only ordnance approved by the Director of UFCE, shall be authorized for use in conducting warning and/or disabling fire.

5. Only those Authorized Officers/Agents who have successfully completed UFCE- approved training are authorized to utilize warning shots and/or disabling fire.

6. Warning shots and/or disabling fire poses a potential hazard; therefore, good judgment must be exercised at all times. They cannot be fired where there is a reasonable belief that personal injury, death, or unintended property damage will occur. Safety shall always be the first consideration when utilizing warning shots and/or disabling fire.

7. The use of warning shots and/or disabling fire is considered less-lethal force, and shall be reported in accordance with the requirements of this chapter.

E. Emergency Situations

In threatening, emergent situations, Authorized Officers/Agents are authorized to use any available weapon in a manner that is reasonable and necessary for self- defense or the defense of another person.

However, this statement does not authorize the carrying of any weapon for duty use that is not authorized and listed on the UFCE Authorized Equipment List (or specifically approved by the Director of UFCE).

Glossary: Second Monday, October

n. person who lives in a certain place

adj. strange or different in a way that is fascinating, interesting, beautiful; foreign

v. phrase. to step upon, land or property

v. to put money into, for future gain

adj. difficult and dangerous

v. to persuade; to make someone agree

n. destruction or killing of a large part of

adv. in error

- **Policy.10**
- Tucson Sector

territorial jurisdiction:

Internal Affairs

a belief that the action taken was appropriate and justified the need to have

a parallel

the incident being other

n

b. Where the actions of each officer ... and ... appropriate ... application of force ... reasonable and necessary ... articulated ... use of force by the officer ...

... should be referred ... to one ... role of chief counsel ... potential litigation?

3. ... design investigation panel ...

... a conflicting relationship ... to the investigation.

b. The assigned IA investigations ... of interest exists between ... the involved ...

4 designated ... personnel ... report from the Joint Intake Center.

... Standard Investigative procedures.

(... CBP and/or DHS to provide any information that could reasonably lead to disciplinary action against that employee ... then ...

... in accordance with ...

d. Ensure that supervisory ... ensure that any ... disciplinary ... be subject to exclusion from criminal proceeding ... consistent with the standards outlined in Garrity v. New Jersey, 385 U.S. 493 (1966);

e. In appropriate ...

... action; and

... 1.

) the substance of
agency policy and procedures or investigation.

respective

initiate

procedural

conflict

a. indication of criminal

the requirement to cooperate

be subject

identified

via

Force

to

the previous month

consist of

incident

indication

factors that should be referred

memorandum

of Justice

of

faith

representation discretionary,
contingent

performed within the scope of
it is in the interest of

the immediate
aftermath

Tucson Sector

Baseball cap, water bottle, handle fashioned from twine,
wrapped in black plastic, to hide it at night,

aspirin, ephedrine, Gatorade and Red Bull,
insulin, band aids, blister cream, saltine crackers,
tuna, and beans,

hairdryers, high-heels, dirt ground into jeans, sweat-stained
tee shirts and animal print bra,
gloves for winter, socks rolled in a ball,

a bottle of mouthwash, deodorant, discarded work boot,
its laces gone missing, its tread patched with tape,

old sneakers and grocery bags, an empty toothpaste tube,
backpacks, a diaper, a child's water wing,

baby bottle and formula, candy wrappers, canned stew,

candles, crosses, and rosary beads, a bible, and prayer cards
to the migrant saints,

a pocket mirror, meant to signal for help,

a blue book bag flattened, panties hung from a tree.

- **Policy.11**
- Footnote

A.Firearms Proficiency and Training Requirements

1. All Authorized Officers/Agents who carry a CBP-issued firearm must maintain and regularly demonstrate an acceptable level of proficiency.

2. All Office of Field Operations personnel are required, at a minimum, to demonstrate their proficiency in the use of each of the firearms that they are issued two times per year during each of the following training periods:

> a.October through March; and
>
> b.April through September.

3. All other armed CBP personnel are required to demonstrate their proficiency in the use of each of the firearms that they are issued four times per year during the following training periods:

> a.October through December;
>
> b.January through March;
>
> c.April through June; and
>
> d.July through September.

4. Based on operational needs and requirements a RD may require that Authorized Officers/Agents maintain and demonstrate proficiency with additional firearms (e.g., a rifle, shotgun, etc.).

5. Based on operational needs and requirements an AC may require that Authorized Officers/ Agents train and/or demonstrate proficiency with greater frequency (e.g., every three months).

6. An acceptable level of proficiency, pursuant to guidelines established by the Director of UFCE, is based on the following:

> a.Successfully completing an approved CBP qualification course of fire in no more than two consecutive attempts and achieving at least the minimum numerical score, as determined by the Director of UFCE;
>
> b.Demonstrating proper handling techniques and manual dexterity required to safely draw, fire, holster, load, unload and operate the firearm;

c. Demonstrating safe weapon handling skills with the firearm during all firearms training.

d. Successfully completing advanced firearm training exercises (AFTE), pursuant to guidelines established or approved by the Director of UFCE; and

e. Demonstrating appropriate responses to the failure or malfunction of firearms or ammunition, including immediate action drills and weapons clearing procedures.

7. Successful completion of the demonstration of proficiency requirement authorizes the Authorized Officer/Agent to carry that firearm until the last day of the following training period.

8. UFCE will publish advanced firearm training exercises (AFTE) that are required to be completed during firearms training. Responsible supervisory personnel shall ensure that each officer/agent completes AFTE each training period.

9. Each Authorized Officer/Agent must successfully complete, at a minimum, one firearm-based use of force training scenario, approved by the Director of UFCE, on an annual basis.

10. Each Authorized Officer/Agent must successfully complete a night fire or low-light familiarization course of fire, approved by the Director of UFCE, on an annual basis (sunglasses or similar devices may not be used to simulate night or reduced light conditions).

11. During each training period, all Authorized Officers/Agents must receive UFCE-approved training on use of force policy.

12. ROs shall ensure that all Authorized Officers/Agents participate in firearms training each training period. Each training block may include firearms qualifications.

13. Managers/supervisors are responsible for planning schedules to ensure that Authorized Officers/Agents are able to participate in required training and qualifications. Officers/agents are responsible for planning their activities to ensure that they participate in required training and qualifications.

14. When Authorized Officer/Agent is detailed to another duty location and will miss training or qualification at their permanent duty location, the officer/agent shall notify managers/supervisors at the temporary duty location of his or her need to train and qualify during that training period.

15. No portion or stage of any firearms qualification course may be waived or altered without written authorization from the Director of UFCE.

Footnote

Integrated, automated

 under these federal statutory mandates,

 certain aliens may be required

to provide fingerprint scans,

 photographs, facial and iris images.

Entry and exit,

 a system that records arrival and departure,

 verifies, authenticates,

 a physical characteristic,

 an attribute collected, compared

 against a previously collected identifier,

 in accordance with, as used in this notice,

a person.

- **Policy.12**
- TITLE II. Border Security and Trade Facilitation

8. Managers/supervisors are responsible for planning schedules to ensure that Authorized Officers/ Agents are able to participate in required training and qualifications. Officers/agents are responsible for planning their activities to ensure that they participate in required training and qualifications.

9. If an Authorized Officer/Agent is detailed to another duty location and will miss training or qualification at their permanent duty location, the officer/agent shall notify managers/supervisors at the temporary duty location of his or her need to train and qualify during that training period.

10. No portion or stage of any **less**-lethal qualification course may be waived or altered without written authorization from the Director of UFCE.

C. Less-Lethal Device Training and Certification

1. Guidelines and Responsibilities

The following guidelines and responsibilities apply to all CBP less-**lethal** devices, systems and associated equipment. Additional device-specific guidelines are contained in the following subsections.

 a. No Authorized Officer/Agent shall be allowed to carry a less-lethal device until they have successfully completed the UFCE-approved initial course of instruction for such device and have been certified in its use.

 b. Only CBP-certified instructors shall instruct and certify CBP law enforcement personnel as less-lethal device end users/operators or instructors.

 c. Only less-lethal devices, systems and associated equipment authorized by UFCE shall be used for training.

 d. UFCE shall be responsible for development and approval of less-lethal device training **materials** and certification **standards**.

 e. Appropriate safety equipment shall be worn during any less-lethal training.

 f. UFCE shall be responsible for the periodic review of the field training and usage of less-lethal devices, systems **and associated** equipment, in **order** to evaluate compliance with policy and curriculum, as well as to assess their overall safety and effectiveness.

2. OC Spray and CSB

 a. Successful completion/certification in the use of both OC spray and the CSB is required at the basic training academies.

b. Upon successful completion of the OC certification course, an Authorized Officer/Agent shall be issued an OC device and a holder. Such items shall be replaced as necessary without cost to the officer/agent.

c. Upon successful completion of the CSB certification course, an Authorized Officer/Agent shall be issued a baton and a holder. Such items shall be replaced **as necessary** without **cost** to the officer/agent.

3. Electronic Control Weapons (ECWs)

a. Exposure to an ECW is not required for end user/operator certification.

b. End users may opt to participate in exposure training, so long as the training is conducted under the close supervision of CBP-certified ECW instructors and in **a controlled manner** with appropriate safety equipment.

c. The Instructor must obtain a voluntarily-signed waiver/consent from participants before conducting voluntary exposures. If **the end user**'s exposure will be videotaped and used in later training events or training materials, consent must also be **obtained** for the videotaping and later use.

4. Compressed Air Launchers (e.g., PLS and/or FN303)

a. Only Authorized Officers/Agents who are trained and certified in the use of OC spray may be trained and certified to use compressed air launchers.

b. Exposure to FN303 projectiles (either kinetic impact or PAVA) during training is not permitted.

c. Exposure to PLS projectiles is not required for end user/operator certification.

d. End users may opt to participate in PLS exposure training, so long as the training is conducted under the close supervision of CBP-certified instructors and in a controlled manner with appropriate safety equipment.

e. PLS voluntary kinetic impact exposures shall be conducted as follows: All participating officers and agents shall wear appropriate safety equipment (including a paintball face shield and protection for **the** throat, groin and hands) and are permitted to wear additional protective equipment (such as arm and leg protection and/or CBP-issued **body** armor) at **their discretion**. The PLS instructor will launch 1 kinetic impact projectile at the male officer's/agent's chest or a female officer's/agent's thigh from a distance of 20 feet.

5. Munition Launcher (e.g., 40mm) and LLSI-CM

a. Only Authorized Officers/Agents who are trained and certified in **the use of** OC spray may be trained and certified to use munition launchers and LLSI-CM.

b. Exposure to Less-Lethal Specialty Impact (LLSI) devices is not permitted.

c. Exposure to a Less-Lethal Chemical Munition (LLCM) is not required for end user/operator certification.

d. End users may opt to participate in LLCM exposure training, so long as the training is conducted under the **close supervision of** CBP certified LLSI-CM instructors and in a controlled manner with appropriate safety equipment.

D. Failure to Qualify and Remedial Training

1. Authorized Officers/Agents who are unable to demonstrate an acceptable level of proficiency with any firearm or less-lethal device shall have **their authority** to carry that firearm or less-lethal device suspended.

a. The Authorized Officer/Agent shall immediately relinquish the firearm or less- lethal device to the instructor.

b. The officer/agent will be provided with a record of the transfer of such item(s).

2. Following a failure to qualify, the Authorized Officer/Agent shall promptly be scheduled for and attend remedial training with a CBP-certified instructor.

a. Remedial training shall be conducted during normal duty hours and begin as soon as practicable after failure to qualify.

b. Remedial training shall not exceed two hours per day for up to eight additional hours (as needed to demonstrate proficiency).

3. An Authorized Officer/Agent who, after completing remedial firearms training, is unable to demonstrate the required level of proficiency shall:

a. Have the removal of his or her CBP-issued firearm recorded in FACTS; and

b. Not be assigned **to** perform duties that require the carrying of a firearm or less-lethal device and may be **subject to reassignment or removal**.

c. If such inability to demonstrate proficiency is for reasons that are beyond the officer's/agent's control, he or she may be reassigned to a position that does not require the carrying of a firearm.

Such reassignment shall not obligate CBP to pay relocation expenses and shall not involve reassignment to a position which has non-competitive promotion potential **beyond the position** from which **the** officer/agent is reassigned.

d. If such **inability to demonstrate** proficiency is for **reason**s that reasonably appear to be within **the** officer's/agent's control, he or she may be removed from employment in accordance with **applicable laws**, government-wide **regulations** and CBP policies.

4. In instances where an Authorized Officer/Agent is unable to demonstrate the required level of proficiency with a shoulder-fired weapon or less-lethal device, and the authority to carry such weapon/device is revoked, the officer/agent shall not be assigned to duties **that** normally **require the carrying of such** weapon(s)/device(s).

E. Unable to Participate

1. Authorized Absences – Authorized Officers/Agents who are unable to participate in qualifications due to an authorized **absence** shall be excused from such requirement(s) in accordance with the provisions of this subsection.

> a. An authorized absence must be approved, in writing, by the officer's/agent's RO (or his/her designee), and shall generally be limited to circumstances beyond the officer's/agent's control.
>
> b. RO's may, on a case-by-case basis, grant an extension of up to 30 days beyond the last day of the current training period.

2. Officer/Agent on Detail – If an Authorized Officer/Agent is detailed to another duty location and will miss one or more firearms qualification(s) and/or an annual less- lethal device qualification at his or her permanent duty location, the officer/agent shall notify supervisory or management officials at the temporary duty location of his or her need to qualify during that training period.

> a. If the detailed Authorized Officer/Agent is performing duties that normally require the carrying of a firearm and/or less-lethal device, the RO who is responsible for the officer's/agent's temporary duty location shall make reasonable efforts to provide the means and the opportunity for the officer/agent to qualify during that training period.
>
> b. If the detailed Authorized Officer/Agent is **performing** duties that are **routinely performed by** officers/agents who do not carry a firearm and/or less-lethal device, the officer may be exempted from the requirement to qualify until he or she returns to his or her permanent duty location.

3. Exemptions to Qualification Requirements – On a case-by-case basis (and consistent with the requirements of the subsections below) an Authorized Officer/Agent may be granted **an exemption** by the RO **to the** requirement to participate in firearms qualifications and/or annual less-lethal device qualifications.

 a. An exemption (not to exceed 270 days) may be granted:

 (1) Due to a temporary **physical** condition (e.g., injury, surgery, illness or pregnancy) which affects **the** officer's/agent's ability to properly utilize a firearm and/or less-lethal device; or

 (2) Due to **circumstances** beyond the **of**ficer's/agent's **control**.

 b. The time period for an exemption begins from the day it is granted by the RO.

 c. Authorized Officers/Agents requesting a medical exemption must provide their supervisor with a written doctor's recommendation. The recommendation must describe the nature of the disability and the anticipated duration of the disability.

 d. The **authority** to grant these exemptions is limited to ROs, and his/her decision regarding the granting of an exemption, and **the duration thereof,** shall be based on all available relevant information.

 (1) Such information may include the medical documentation submitted by the officer/agent, records of the officer's/agent's prior firearms and/or less- lethal device qualifications and the recommendations of the Firearms Instructor(s) and/or Less-Lethal Instructor(s) and supervisory personnel.

 e. Authorized Officers/Agents granted an exemption from qualifying shall receive a written authorization to continue carrying firearm(s) and/or less-lethal device(s).

 (1) The written notice shall include a specific expiration date of the exemption, and a description of the firearm(s) and/or less-lethal device(s) **the** officer/agent is authorized to carry.

 f. An exemption shall not be granted for non-physical conditions or mental **trauma related** to mental illness deemed by a mental health professional to adversely affect the Authorized Officer's/Agent's judgment regarding the use of force. Such mental disability shall require immediate revocation of authority to carry a firearm and/or less-lethal device.

F. Exposure to Oleoresin Capsicum (OC) Spray

One **exposure** to OC spray shall be **required as** part of the **basic certification** course for Authorized Officers/ Agents to carry OC.

1. As part of the basic training at the CBP academies, officers/agents shall be exposed **as part of** the course of **instruction**.

2. Authorized Officers/Agents who have already completed the basic academy prior to the effective date **of** this **policy,** but who have not been exposed to OC, are not required to be exposed but are required to attend the OC re-certification course and participate in less-lethal training.

TITLE II. Border Security and Trade Facilitation

Situational awareness is knowledge and understanding of current illicit cross-border activity, individual cross-border threats and trends concerning illicit trafficking and unlawful crossings, and the ability to forecast future shifts in threats and trends.

Got away is an illegal border crosser who, after making illegal entry into the U.S., is not turned back or apprehended.

Consequence delivery system is a series of consequences applied to persons illegally entering the U.S. by Border Patrol to prevent illegal border crossing recidivism.

High traffic areas are sectors along the north and south borders of the U.S. that are within the responsibility of the Border Patrol that have the most illicit cross-border activity, informed through situational awareness.

Illegal border crossing effectiveness rate is the percentage resulting from dividing the number of apprehensions and turn backs by the number of apprehensions, turn backs, and got aways.

A *major violator* is a person or entity who has engaged in serious

criminal activities at any land, air, or sea port of entry.

Operational control is a condition in which there is not lower

than ninety percent of illegal border crossing effectiveness rate,

informed by situational awareness, and significant reduction in the movement

of illicit drugs and other contraband through such areas being achieved.

Turn back is an illegal border crosser who,

after making an illegal entry,

returns to the country from which they entered.

- **Policy.13**
- ~~TITLE II. Border Security and Trade Facilitation~~
- The Maggot Allegations

Chapter 7: CBP Body Armor

a. General Guidelines and Responsibilities

1. Authorized Officers/Agents (and other employees as approved) shall be issued personal protective body armor.

 a. The minimum ballistic threat protection level of new CBP-issued body armor shall be Level IIIA, as certified by and in accordance with the standards of the National Institute of Justice (NIJ).

 b. Body armor that has exceeded its expiration date (as listed in FACTS) or become unserviceable shall be replaced (as funds are available).

 c. Body armor carriers and accessories that become unserviceable shall be replaced (as funds are available).

2. CBP employees who are issued body armor are responsible for the general care, maintenance and safekeeping of body armor in accordance with the requirements of Chapter 8 and the manufacturer's recommendations and ballistic panel labeling.

3. CBP employees who are issued body armor are required to complete mandatory CBP-approved body armor training.

4. CBP employees changing duty locations or duty assignments within CBP (and whose new position requires/is authorized for body armor) shall retain their assigned body armor.

5. [redacted] CBP employees (transferring to other agencies, [redacted] [redacted] their body armor to their Body Armor Coordinator (BAC) and complete the [redacted] the transfer in FACTS.

6. BACs (or other designated personnel who have received training in the characteristics, care, and maintenance of soft body armor) are responsible for [redacted] of needs for body armor, ensuring that [redacted] and conducting [redacted] and inventory of all body armor as required.

7. BACs should maintain [redacted] sizes of [redacted] [redacted] [redacted] to replace body armor in a [redacted]

[redacted]

Any unissued ~~body armor in~~ excess ~~of 50~~ ~~should be transferred/sent to UFCB.~~

~~b. Body armor held on behalf of CBP employees~~ ~~on leave or detail, or new armor awaiting~~ ~~initial issue, shall not count~~ against the limits outlined ~~in this subsection.~~

~~8. Unserviceable body armor shall be transferred/sent to~~ ~~UFCB for processing and destruction.~~

~~B. Policy on the Wear of Body Armor~~

~~1. CBP strongly encourages~~ the use of body ~~armor at all~~ ~~times while performing law enforcement duties.~~

~~2. While~~ the wearing of ~~body armor during~~ normal ~~operations is at the discretion of the employee, managers~~ ~~may~~ mandate ~~the wearing of body armor in a limited number~~ ~~of high-risk situations or during activities as specified~~ ~~in subsection 3 below.~~

~~3. The wear of body armor by all~~ ~~employees is mandatory~~ ~~during the following activities:~~

~~a. Firearms training~~ ~~and qualification (after being~~ ~~issued body armor);~~

~~b. Special response team deployments, when~~ ~~part of an arrest, entry,~~ ~~or perimeter element;~~

~~c. Execution of high-risk search or arrest~~ ~~warrants, terrorism related or other high-risk~~ ~~operations, and specialty unit operations~~ ~~as directed by the CBP operational component~~ ~~Assistant Commissioner (AC) or Chief;~~

~~d. Air and marine operations, as directed~~ ~~by the AC of the Office of Air and Marine~~ ~~(OAM);~~

~~e.~~

~~f. Emergency situations when management~~ ~~determines that there is an immediate threat to~~ ~~the safety of the employee (affected employees~~ ~~will be notified that the wearing of body armor is~~ ~~required); and~~

~~g. When practical, for the~~ ~~transportation, storage or destruction~~ ~~of safe ammunition, currency, or other~~ ~~high-risk or valuable commodities.~~

4. When CBP employees are required to wear body armor, they will be provided opportunities to rehydrate and remove the body armor when practicable.

███

a. This exemption pertains to officers/agents who will be working in close proximity to violators who may identify the officer/agent as a law enforcement officer if he or she is wearing body armor.

b. In all cases, the exemption must be approved by a supervisor.

C. Replacement of CBP-Issued Body Armor

1. CBP employees are responsible for requesting the issuance of replacement body armor, as needed, and for ensuring that their issued armor has not exceeded its designated replacement date (as listed in FACTS).

2. CBP employees issued body armor shall, as soon as practicable, notify their supervisor of the need to replace lost, stolen, worn, damaged, or ill-fitting body armor, should such a need be identified between periodic inspections.

3. Body armor measurements and officer/agent information shall be entered into the FACTS Body Armor Request Form by the BAC, where it must be approved by the respective operational component and forwarded to UFCE for processing.

4. Once replacement body armor has been received and issued to the employee, the previously issued armor shall be transferred to the BAC. Unserviceable armor shall be transferred/sent to UFCE for processing and destruction.

███

D. Storage and Accountability for CBP Body Armor

1. Body armor shall be stored in accordance with the requirements of Chapter 8.H.

2. Body armor shall be inventoried/accounted for in accordance with the requirements of Chapter 8.C.

3. Body armor that is lost or stolen shall be replaced in accordance with the requirements of Chapter 8.D.

E. Testing, Acquisition and Disposal

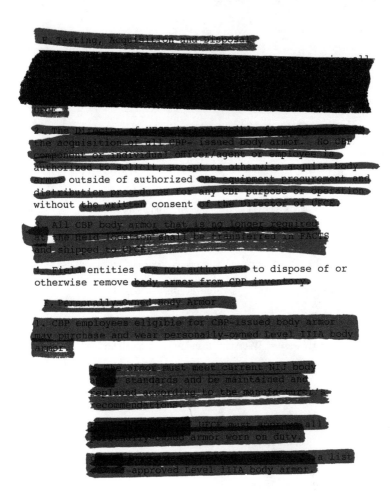

UFCE.

2. The Director of UFCE is responsible for
the acquisition of all CBP- issued body armor. No CBP
component or individual officer/agent or employee is
authorized to solicit, accept or otherwise acquire body
armor outside of authorized CBP equipment procurement and
distribution procedures for any CBP purpose or operation
without the written consent of the Director of UFCE.

c. All CBP body armor that is no longer required
at the field location shall be transferred in FACTS
and shipped to UFCE.

d. Field entities are not authorized to dispose of or
otherwise remove body armor from CBP inventory.

F. Personally-Owned Body Armor

1. CBP employees eligible for CBP-issued body armor
may purchase and wear personally-owned Level IIIA body
armor.

2. armor must meet current NIJ body
standards and be maintained and
replaced according to the manufacturer's
recommendations.

UFCE must approve all
personally owned armor worn on duty

a list
-approved Level IIIA body armor.

The Maggot Allegations

1.

You can bet that the facility was never in any danger

 of receiving even one Michelin star.

But the complaints being made by detainees, are not nearly the kind you'd expect

if the facility had been serving maggot-ridden food:

 Too many sandwiches and no condiments. Too many onions,

 they smell up the food & tray. They serve the same food all the time.

 Would like to have cheese and jalapeño peppers, and tomatoes/salsa

 added to the scrambled eggs. Rice – over/under cooked.

 Want more coffee. Too many eggs. Cups & spoons –

 not properly washed. Want more than just white bread for sandwiches,

want more tortillas.

2.

I suspect that if true, it was not maggots but rather the larvae of pantry moths.
I speak from experience when I say that pantry moths are hard to get rid of.
For what it is worth, they are less likely to carry pathogens than houseflies.

3.

As the report puts it, "One individual testified to have seen maggots in food while visiting."

 Here's what Ms. H. actually stated before the Commission—

that somebody else saw the maggots:

She had heard the complaints about food and couldn't believe her eyes

 when a detainee brought her a napkin with a scoop of oatmeal, rice, beans

and when she opened up the napkin, it had squirming live maggots.

 And this is what detainees were expected to eat.

Ms. H. appears to have heard the story from a Commissioner S.

who in turn heard it from Ms. C.

Even if the statement was true, and accurate in terms of firsthand observation,

that would still not answer the question of where the napkin full of food came from.

Did the detainee who presented it to her take it off his own plate?

Or did he get it from another?

If he got it from another detainee, where did that detainee get it?

It is odd that food that requires cooking—like oatmeal and rice & beans—

would have live, squirming maggots in it; one would expect them to be cooked.

It is also odd that oatmeal and rice & beans would be served together

in the same meal. Is it possible this food was taken from the garbage pail

instead of from a plate?

We *can*, ask these questions, but have probably arrived too late to get answers.

- **Policy.14**
- Aviso al Pueblo
- Glossary: Third Monday, February

A. General Guidelines and Responsibilities

1. Each Authorized Officer/Agent shall be responsible for the general care, maintenance and safekeeping of CBP-issued firearms, body armor and other use of force equipment.

 a. Authorized Officers/Agents are expected to exercise good judgment in providing sufficient security for CBP-issued use of force equipment to protect against theft or unauthorized use.

 b. Authorized Officers/Agents may be subject to disciplinary action if CBP-issued use of force equipment is lost or stolen, and a determination is made that the officer/agent was negligent or used poor judgment in safeguarding that equipment.

B. The Firearms, Armor and Credentials Tracking System (FACTS)

 1. The Firearms, Armor and Credentials Tracking System (FACTS) provides oversight and lifecycle accountability for specified law enforcement assets and equipment (including firearms, body armor, ECWs and munition launchers).

 2. All assigned law enforcement assets must have accountability and lifecycle data recorded in FACTS, including acquisition, issuance, repair, transfer, loss (if applicable) and destruction.

 3. Prior to the separation of an employee from CBP, the immediate supervisor is responsible for ensuring that all assigned assets in FACTS have been turned in to the appropriate coordinator, and that action has been recorded in FACTS.

 4. Responsible Officials (ROs), managers and supervisors are responsible for ensuring that the data contained in FACTS is accurate.

 5. The Director of UFCE is responsible for providing policy direction and general oversight of FACTS.

 6. Firearms Coordinators (FCOs) must notify UFCE when a FACTS asset undergoes any atypical change of disposition (e.g., use for competition, machine being held as evidence, etc.).

c. Inventory of Accountable Assets in FACTS

Director of UFCE shall direct an inventory for
enforcement assets that are accountable in FACTS
at once per ... inventories
may be directed as necessary.

2. Firearms Instructors shall physically verify the
numbers of all assigned ...
... trations of property and enter them into
FACTS.

3. Authorized Officers/Agents shall physically
... possession and
record such action as required in FACTS.

4. Supervisors shall physically verify an employee's
inventoried property and record such action as
required in FACTS.

5. POs, managers and ... for their
organizational elements.

d. Lost or Stolen Firearms, Body Armor and/or Other
Equipment in FACTS

... a law enforcement asset that is accountable in
... is lost or stolen, it shall be reported as
follows:

a. ... shall report the loss to a
... hours of the discovery
of the loss or theft).

... of a loss or theft, the
supervisor shall:

... loss or theft is reported
immediately through the chain of command, to
the Commissioner's Situation Room and to the
Joint Intake Center (JIC);

(2) Ensure that the make, model and serial
number are entered into the National Crime
Information Center (NCIC) database (within 24
hours); and

... Ensure that the accountable officer/agent
... a loss action in FACTS (within 24
hours).

Detailed instructions for completing this process
are outlined in the applicable Standard Operating
Procedures ... available in the UFCE section of
CBPnet Secure.

... applicable local
law enforcement reporting requirements.

When a CBP issued firearm has been lost or stolen [redacted] (as long as the authority to carry a firearm has not been revoked) [redacted]

a. A replacement CBP-issued firearm; and

b. The opportunity to familiarize himself or [redacted] replacement firearm under the supervision of a FI [redacted]

[redacted] qualify with the replacement firearm as soon as practicable.

[redacted] armor will be replaced as soon as practicable.

[redacted] Property Management Oversight Board (PPMOB)

1. The PPMOB should meet within thirty days of receipt of a Report of Survey.

2. UFCE is responsible for documenting the PPMOB findings in FACTS in order to terminate the asset record.

E. Requests for Firearms/Assets in FACTS

[redacted] Requests for firearms [redacted] assets shall be **initiated** [redacted] and approved in FACTS.

a. The appropriate FACTS coordinator shall request the assets from UFCE, with the concurrence/approval of the RO or COA.

b. Requests for firearms/other assets [redacted] reviewed/approved by operational [redacted] personnel and the [redacted] Director for UFCE.

G. Transfers of Accountability in FACTS

1. CBP employees shall [redacted] electronically transfer [redacted] assets [redacted] FACTS Transfer Action.

2. [redacted] employee receiving the asset must also promptly accept it in FACTS (within three days of receipt).

3. Accountability [redacted] accepted in the system.

4. All unissued (or pool) firearms and/or other unissued assets that **are accountable** in FACTS shall be assigned to the appropriate FACTS Coordinator for [redacted] office.

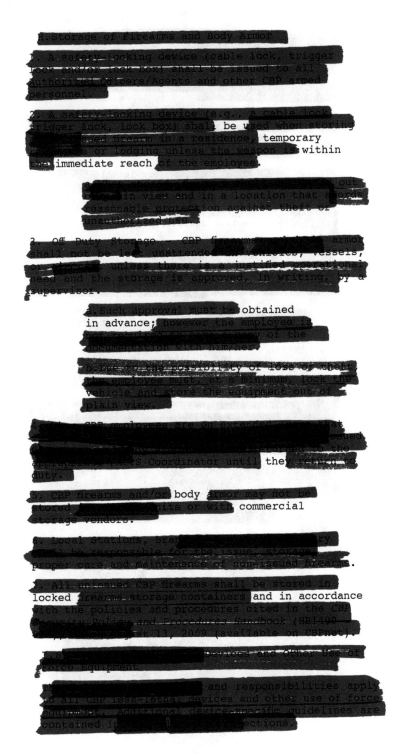

d. Storage of Firearms and Body Armor

1. A safety locking device (cable lock, trigger lock and/or lock box) shall be issued to all authorized Officers/Agents and other CBP armed personnel.

2. A safety locking device (e.g., a cable lock, trigger lock, lock box) shall be used when storing ████████████ in a residence, temporary ████████ or lodging unless the weapon is within ████ immediate reach of the employee.

████████████████████████████████ out ████ in view and in a location that ████ reasonable protection against theft or unauthorized use.

2. Off Duty Storage. CBP firearms ████ ███ armor shall not be left unattended ███ vehicles, vessels, or ████████ unless there is a justified operational need and the storage is approved, in writing, by a supervisor.

a. Such approval must be obtained in advance; however the employee is ███ required ████████████████ of the documentation with num/her.

b. The ████████ possibility of loss or theft ██, employee must, ████ minimum, lock the vehicle and store the equipment out of plain view.

█████ CBP employees are on extended ████ ███ ████████████████████████████ issued ████████████████████ returned to the appropriate ████'s Coordinator until they return to duty.

5. CBP firearms and/or body armor may not be stored ████████████ lts or with commercial storage vendors.

6. Local Stations, Bran█████████████████████ ry ████████ responsible for the issuer, storage, proper care and maintenance of non-issued firearms.

7. All unissued CBP firearms shall be stored in locked firearms storage containers and in accordance with the policies and procedures cited in the CBP ███████ Policy and Procedures Handbook (HB1400-██), ████████ st 13, 2009 (available on CBPnet).

████████████████████████████ Batons and Other Use of Force Equipment.

█████████████████████ and responsibilities apply to all CBP less-lethal devices and other use of force equipment. ████████████ device-specific guidelines are contained in ████████████ sections.

1. Responsible CBP supervisory personnel shall ensure that CBP less-lethal devices ▮▮▮▮ ▮▮▮▮▮▮▮▮▮ equipment (when not ▮▮▮▮▮▮▮▮ stored in a limited access location and in a manner ▮▮▮▮▮▮▮▮▮▮▮▮ the manufacturer's sugge▮▮▮▮▮▮▮▮▮▮rage.

2. Local Stations, Branches and Ports of Entry shall be responsible for the issue, storage, proper care and main▮▮▮▮▮▮▮▮▮ less-lethal devices and other use of ▮▮▮▮▮▮ ▮pment.

3. When ▮▮▮▮▮▮▮ CBP-issued less-lethal device ▮▮▮▮▮▮▮▮▮▮▮▮▮▮ equipment in a residence, temporary residence or lodging, it shall be stored out of plain view and in a location that affords reasonable protection against theft or unauthorized use.

4. Off Duty Storage — CBP less-lethal devices and other use of force equipment that is accountable in FACTS shall not be left unatt▮▮▮▮▮ ▮ vehicles, vessels, or aircraft unless there ▮▮▮▮ justified operational need.

a. Such approval must be obtained in advance ▮▮▮▮▮▮▮▮▮▮▮▮▮▮▮▮▮▮▮▮▮▮▮▮▮▮▮▮▮▮▮▮ have a copy of the documentation with him/her.

b. Due to the possibility ▮▮▮▮▮▮▮▮▮▮▮▮▮ employee must, at ▮▮▮inim▮▮▮▮▮▮▮▮ vehicle and store the equ▮▮▮▮▮t ▮▮▮▮▮▮▮▮▮ew.

5. When CBP employees are on extended leave that is expected to ▮▮▮▮▮▮▮tively days, their CBP ▮▮▮▮▮▮less-lethal devi▮▮▮▮▮▮ other use of force ▮▮▮▮▮▮▮▮▮▮al be retu▮▮▮▮▮▮▮▮ appropriate coordinator until they return to duty.

6. ▮▮▮▮▮▮▮▮▮ devices or other use of force equipment may not be stored in ▮▮▮▮▮▮units ▮ with commercial storage vendors.

J. Storage of Less-Lethal Devices — Device-Specific Guidelines

1. Electronic Control Weapons (ECWs)

a. ▮▮▮▮▮nsible CBP supervisory personnel shall ▮▮▮▮▮▮▮▮that ECWs (when not in use) are stored with the batteries in and the cartridges removed.

2. Compressed Air Launchers

a. When left unattended for short periods of time, compressed air launchers must be stored in a locked service vehicle, trunk, or other limited access location or in a secure CBP-issued container.

Aviso al Pueblo

Lo que usted tiene que saber sobre las directrices de inmigración recién

anunciadas:

Estados Unidos está dando prioridad a la deportación inmediata

de personas que cruzan la frontera sin la documentación adecuada.

Estas directrices no proporcionan beneficios a personas

que actualmente viven fuera de los Estados Unidos, tampoco a quienes

han entrado recientemente al país, ni a quien hoy intenta cruzar la frontera

sin documentos.

Personas que viven en los Estados Unidos que traten de enviar a sus hijos

sin documentos, no serán elegibles bajo estas directrices.

La ley migratoria de los Estados Unidos no hay "permisos" para quienes

intentan cruzar la frontera sin documentos, al contrario,

serán prioridad para la deportación inmediata.

Si alguna persona le dice o promete algo diferente, por favor, no le crea.

Glossary: Third Monday, February

n. a mixture or collection of dissimilar things

n. a large number of; many

adv. assumption or belief that something is true

adj. not willing; hesitant

v. to cause, to set in motion; suddenly

v. to withdraw from

v. to break apart

- **Policy.15**
- Apprehension, Detention, and
 Removal of Other Aliens

3. Less-Lethal Specialty Impact - Chemical Munitions (LLSI-CM)

a. LLSI-CM shall be stored in a safe and secure area. Requirements for the storage of LLSI-CM will be the same as for ammunition and firearms. The munitions must be stored in a secure room that meets the requirements of the *CBP Security Policy and Procedures Handbook (HB1400-02B)*, dated August 13, 2009 (available on CBPnet).

b. A Department of Transportation (DOT) 1.4D explosive placard will be posted on the door of CBP LLSI-CM storage site (contact OTD/UFCE if further guidance is needed).

c. When left unattended for short periods of time, LLSI-CM must be stored in a locked service vehicle, trunk, or other limited access location or in a secure CBP-issued container.

4. Controlled Noise and Light Distraction Devices (CNLDDs)

a. All unissued CBP CNLDDs shall be stored in locked storage containers and in accordance with the policies and procedures cited in the *CBP Security Policy and Procedures Handbook (HB1400-02B)*, dated August 13, 2009 (available on CBPnet) and/or in accordance with Bureau of Alcohol, Tobacco, Firearms and Explosives (ATF) guidelines (see e.g., ATF Ruling 2009-3 and ATF Publication 5400.7).

b. Annual inventories of CNLDDs will be conducted, and any lost, stolen or missing CNLDDs will be noted and forwarded to appropriate supervisory personnel.

c. CNLDDs shall not be stored in residences, vehicles, vessels, or aircraft overnight (or equivalent) unless there is a justified operational purpose and it is approved, in writing, by a supervisor.

(1) Such approval must be obtained in advance; however the employee is not required to have a copy of the documentation with him/her.

(2) To receive approval for storage of a CNLDD under this subsection it must be able to be secured in a residence or to a vehicle, vessel, or aircraft by locked chain, cable, or CBP-approved safety-locking device and concealed from view.

J. Unissued Firearms

1. The maximum allowable number of unissued firearms for each type of handgun is limited to 5% of the number of officers/agents at the duty location. For smaller duty locations (less than 100 officers/agents) up to 5 unissued handguns are authorized.

1. The number of handguns authorized to be retained in reserve as unissued by the Director of UFCE shall be 10% of the total number of Authorized Officers/Agents.

2. The maximum allowable number of each type of Shoulder Fired Weapon (SFW) is limited to 105% of the number of Authorized Officers/Agents at the duty location.

3. The number of SFWs authorized to be retained in reserve as unissued by the Director of UFCE shall be 5% of the total number of Authorized Officers/Agents.

4. Firearms held on behalf of officers/agents on leave or detail, for repair, or for use in training or ceremonial duties shall not count against the limits outlined in this subsection.

5. For special weapons in support of specific missions, the type, number, and deployment shall be determined by the appropriate RO with the written concurrence of the AC of the operational component.

K. Non-Standard Firearms

1. The AC of the respective operational component may, with concurrence of the Director of UFCE, approve requests from an RO for a non-standard firearm.

2. Requests for authorization to carry non-standard firearms must be submitted through FACTS for approval by the RO and the Director of UFCE. Specific mission needs must be addressed in the form.

3. Authorizations are valid for the time period specified, or until revoked by the RO or the Director of UFCE.

4. Non-standard firearms shall be transferred, stored, inventoried and accounted for in accordance with the requirements of this chapter.

5. Responsible supervisory personnel shall ensure that the CBP employees using non-standard firearm(s) have qualified with the firearm(s) in accordance with this policy.

L. Acquisition, External Transfer or Destruction of FACTS Assets

1. UFCE is the only authorized entry and exit point for all CBP firearms, less-lethal devices, and other use of force equipment that is accountable in FACTS.

2. No entity outside of UFCE is approved to loan or transfer CBP firearms, less-lethal devices, or other use of force equipment that is accountable in FACTS to another agency or to individuals within another agency without the written approval of the Director of UFCE.

A. Inspection of CBP Firearms

1. UFCE shall receive and inspect ALL newly acquired firearms to ensure proper functioning and compliance with CBP specifications and standards.

2. A CBP Field Armorer (FA) or Firearms Instructor (FI) shall inspect all CBP-issued firearms during qualification periods to ensure safe and proper functioning.

3. Only UFCE-authorized optics, lights and slings may be mounted on a CBP- issued firearm. A list of authorized optics, lights and slings may be found on the UFCE Authorized Equipment List.

4. UFCE has the authority to recall and/or inspect any CBP-issued firearm as necessary.

B. Maintenance of CBP Firearms

1. All armed CBP employees are responsible for normal cleaning and preventive maintenance of their CBP-issued firearms. During normal training operations, firearms shall be cleaned as soon as practicable after being fired.

2. FIs shall provide Authorized Officers/Agents with training regarding proper care, maintenance, and inspection procedures. This training shall be incorporated into the training curriculum each training period.

3. Authorized Officers/Agents shall be provided with sufficient materials and sufficient duty time (consistent with operational needs) to clean their CBP-issued weapons. A failure to perform normal cleaning and preventative maintenance may result in disciplinary action.

4. Maintenance should only be done in accordance with the instructions provided by UFCE or as described in the operator manuals for that particular firearm. Operator manuals shall be made available to all employees for each of their CBP-issued firearms.

5. FIs shall ensure that all unissued or pool weapons used in training, practice, or qualification sessions are cleaned and preventive maintenance performed prior to returning the weapon to storage.

NOTE: Firearms should not be cleaned if they have been involved in a reportable use of force, or in an unintentional discharge where a malfunction is suspected.

C. Repair of CBP Firearms

1. CBP employees (except those certified and designated as FAs) are prohibited from making any repairs, adjustments and/or modifications to CBP-issued firearms unless expressly authorized by the Director of UFCE.

2. CBP-certified FAs are authorized to make certain repairs and/or modifications, as provided in FA training, and subsequent UFCE-directed repairs and/or modifications.

3. Firearms requiring repairs beyond FA authorization shall be transferred and shipped to UFCE in accordance with the procedures outlined in the UFCE Standard Operating Procedures (available on CBPnet Secure).

D. Inspection of CBP Less-Lethal Devices or Other Use of Force Equipment

1. UFCE shall receive and inspect ALL newly acquired CBP use of force equipment that is accountable in FACTS to ensure proper functioning and compliance with CBP specifications and standards.

2. Less-Lethal Instructors (LLIs) shall inspect all less-lethal devices annually.

3. If CBP use of force equipment that is accountable in FACTS becomes damaged or nonfunctional, it shall be transferred and shipped to UFCE in accordance with the procedures outlined in the UFCE Standard Operating Procedures (available on CBPnet Secure).

4. UFCE has the authority to recall and/or inspect any CBP less-lethal device or other use of force equipment that is accountable in FACTS as necessary.

E. Maintenance of CBP Less-Lethal Devices or Other Use of Force Equipment

1. All CBP employees are responsible for normal cleaning and preventive maintenance of their CBP-issued less-lethal devices and equipment.

2. LLIs shall provide Authorized Officers/Agents with training regarding proper care, maintenance, and inspection procedures. This training shall be incorporated into the training curriculum each training period.

3. Authorized Officers/Agents shall be provided with sufficient materials and sufficient duty time (consistent with operational needs) to clean their devices. A failure to perform normal cleaning and preventative maintenance may result in disciplinary action.

4. Maintenance should only be done in accordance with the instructions provided by UFCE or as described in the operator manuals for that particular device.

Apprehension, Detention, and Removal of Other Aliens

Nothing in this memorandum should be construed to prohibit or discourage

the apprehension, detention, or removal of aliens unlawfully

in the United States who are not identified as priorities herein.

However, resources should be dedicated, to the greatest degree possible,

to the removal of aliens described in the priorities set forth above,

commensurate with the level of prioritization identified.

Immigration officers and attorneys may pursue removal of an alien

not identified as a priority herein,

provided removing such an alien would serve an important federal interest.

• Notes

This book consists of a series of linked documentary poems composed of appropriated language from U.S. government documents, such as: Customs and Border Patrol handbooks; the Immigration and Nationality Act; the U.S. patent for Taser hand-held stun guns; and materials from the Office of English Language Programs designed to instruct immigrants on assimilation into U.S. culture. I consider such texts material objects that have the capacity to affect an embodied subject both discursively and physically. For example, one such text appropriated for the book, the U.S. Customs and Border Protection's *Use of Force Policy, Guidelines and Procedures Handbook*, discursively constructs a criminalized *other* while authorizing physical harm to that other. The handbook defines subjects based on their level of resistance to a CBP officer and assigns material consequences to that definition, like being subjected to pepper spray or to "stunning techniques, takedowns, joint manipulations and use of an Electronic Control Weapon." The language that defines, criminalizes, and authorizes physical harm to these subjects, however, is buried within 117 pages of institutional language, in a handbook that is not meant for the public. In the book I excavate this language and lay it bare in the form of poems that document the underlying mechanics of power inherent in these texts.

...

The poem *Tucson Sector* documents material culture at the busiest Border Patrol sector in Tucson, AZ. Prior to crossing the U.S.-Mexico border, migrants discard any items that could mark them as "illegal aliens."

...

Language from the following U.S. government sources was used in the construction of poems for this book:

S. 2611- Helping Unaccompanied Minors and Alleviating National Emergency Act (HUMANE Act), Senator John Cornyn (R-Texas), introduced July 15, 2014.

The dissenting statement of Civil Rights Commissioner Gail

Heriot in the United States Commission on Civil Rights 2015 Statutory Enforcement Report, "With Liberty and Justice for All: The State of Civil Rights and Immigration Detention Facilities."

The "Derechos y Responsabilidades del Ciudadano," United States Citizenship and Immigration Services website.

Preparation Manual for the U.S. Border Patrol Entrance Examination, by U.S. Department of Homeland Security Customs and Border Protection.

Policies for the Apprehension, Detention and Removal of Undocumented Immigrants, U.S. Department of Homeland Security.

Estate of Anastacio Hernandez-Rojas et al v. United States of America et al.

S. 2611- Helping Unaccompanied Minors and Alleviating National Emergency Act (HUMANE Act), Senator John Cornyn (R-Texas), introduced July 15, 2014.

CBP Use of Force Policy, Guidelines and Procedures Handbook, by U.S. Customs and Border Protection.

"United States Visitor and Immigrant Status Indicator Technology Program ("US-VISIT"); Enrollment of Additional Aliens in US-VISIT; Authority To Collect Biometric Data From Additional Travelers and Expansion to the 50 Most Highly Trafficked Land Border Ports of Entry," A Rule by the Homeland Security Department on 12/19/2008, *The Federal Register*

National Forum on Education Statistics, Race/Ethnicity Data Implementation Task Force. (2008). *Managing an Identity Crisis: Forum Guide to Implementing New Federal Race and Ethnicity Categories* (NFES 2008-802). National Center for Education Statistics, Institute of Education Sciences, U. S. Department of Education. Washington, DC.

Celebrate! Holidays in the U.S.A., by the Office of English Language Programs, United States Department of State.

United States Patent US 6,636,412 B2, *Hand-Held Stun Gun for Incapacitating a Human Target*, and *Mattos v. Agarano*, United States Court Of Appeals For The Ninth Circuit.

"Test To Collect Biometric Information at Up to Ten U.S. Airports ("Be-Mobile Air Test")," A Notice by the U.S. Customs and Border Protection on 07/28/2015, *The Federal Register.*

U.S. Border Security, Economic Opportunity, and Immigration Modernization Act.

Know the Facts, U.S. Customs and Border Protection public information campaign.

Policies for the Apprehension, Detention and Removal of Undocumented Immigrants, U.S. Department of Homeland Security.

"Less Lethal Launcher," Solicitation Number: 2009-FN303-RAT, Federal Business Opportunities website.

About **Francesco Levato**

Francesco Levato is a poet, a literary translator, and a new media artist. Recent books include Arsenal/ Sin Documentos; Endless, Beautiful, Exact; Elegy for Dead Languages; War Rug, a book length documentary poem; Creaturing (as translator); and the chapbooks A Continuum of Force and jettison/collapse. He has collaborated and performed with various composers, including Philip Glass, and his cinépoetry has been exhibited in galleries and featured at film festivals in Berlin, Chicago, New York, ███████████ and elsewhere. He founded the Chicago School of Poetics, holds an MFA in Poetry and a PhD in English Studies, and is currently an Assistant Professor of Literature & Writing Studies at California State University San Marcos.

Other Books by **CLASH** Books

**TRAGEDY QUEENS: STORIES INSPIRED BY LANA DEL REY &
SYLVIA PLATH**
Edited by Leza Cantoral

GIRL LIKE A BOMB
Autumn Christian

CENOTE CITY
Monique Quintana

**99 POEMS TO CURE WHATEVER'S WRONG WITH YOU OR CREATE
THE PROBLEMS YOU NEED**
Sam Pink

THIS BOOK IS BROUGHT TO YOU BY MY STUDENT LOANS
Megan J. Kaleita

PAPI DOESN'T LOVE ME NO MORE
Anna Suarez

THIS IS A HORROR BOOK
Charles Austin Muir

I'M FROM NOWHERE
Lindsay Lerman

HEAVEN IS A PHOTOGRAPH
Christine Sloan Stoddard

FOGHORN LEGHORN
Big Bruiser Dope Boy

PIXEL BOY IN POETRY WORLD
S.T. Cartledge

TRY NOT TO THINK BAD THOUGHTS
Matthew Revert

SEQUELLAND
Jay Clayton-Joslin

JAH HILLS
Unathi Slasha

GIMME THE LOOT: STORIES INSPIRED BY NOTORIOUS B.I.G
Edited by Gabino Iglesias

NEW VERONIA
M.S. Coe

THE MISADVENTURES OF A GILTED JOURNALIST
Justin Little

SPORTS CENTER POEMS
Poetry by Christoph Paul & Art by Jim Agpalza

TRASH PANDA
Leza Cantoral

THE HAUNTING OF THE PARANORMAL ROMANCE AWARDS
Christoph Paul & Mandy De Sandra

GODLESS HEATHENS: CONVERSATIONS WITH ATHEISTS
Edited by Andrew J. Rausch

DARK MOONS RISING IN A STARLESS NIGHT
Mame Bougouma Diene

GODDAMN KILLING MACHINES
David Agranoff

NOHO GLOAMING & THE CURIOUS CODA OF ANTHONY SANTOS
Daniel Knauf (Creator of HBO's Carnivàle)

IF YOU DIED TOMORROW I WOULD EAT YOUR CORPSE
Wrath James White

THE ANARCHIST KOSHER COOKBOOK
Maxwell Bauman

HORROR FILM POEMS
Poetry by Christoph Paul & Art by Joel Amat Güell

NIGHTMARES IN ECSTASY
Brendan Vidito

THE VERY INEFFECTIVE HAUNTED HOUSE
Jeff Burk

ZOMBIE PUNKS FUCK OFF
Edited by Sam Richard

THIS BOOK AIN'T NUTTIN TO FUCK WITH: A WU-TANG TRIBUTE ANTHOLOGY
Edited by Christoph Paul

WALK HAND IN HAND INTO EXTINCTION - STORIES INSPIRED BY TRUE DETECTIVE
Edited by Christoph Paul & Leza Cantoral

Printed in the USA
CPSIA information can be obtained
at www.ICGtesting.com
JSHW012053140824
68134JS00035B/3409

9 781944 866419